The Art of Cartooning

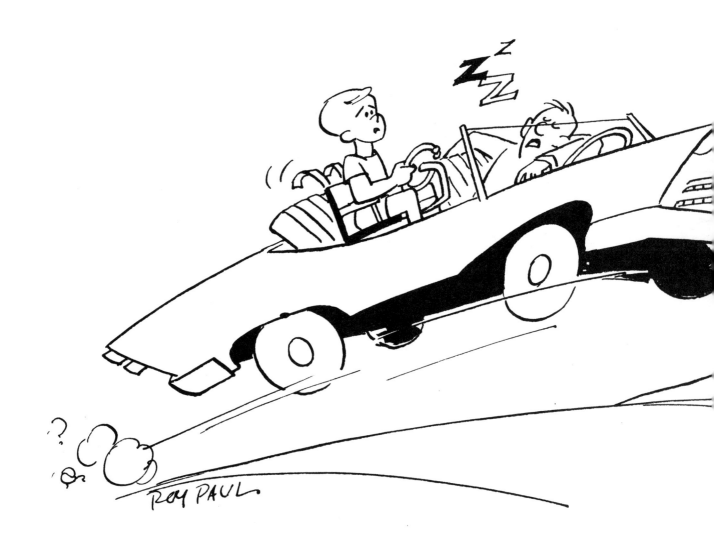

THE ART OF
Cartooning

Roy Paul Nelson

Dover Publications, Inc.
Mineola, New York

Bibliographical Note

This Dover edition, first published in 2004, is an unabridged republication of *Fell's Guide to the Art of Cartooning*, published by Frederick Fell, Inc., New York, 1962.

Library of Congress Cataloging-in-Publication Data

Nelson, Roy Paul.
 [Fell's guide to the art of cartooning]
 The art of cartooning / Roy Paul Nelson.
 p. cm.
 Published in New York in 1962 under title: Fell's guide to the art of cartooning.
 ISBN 0-486-43639-X (pbk.)
 1. Cartooning—Technique. I. Title.

NC1764.N45 2004

2004049361

Manufactured in the United States of America
Dover Publications, Inc., 31 East 2nd Street, Mineola, N.Y. 11501

For My Mother and Father and Rod

Contents

Introduction

The cartoonist sits at his thumbtack-scarred drawing table in a room cluttered with drawing tools and pictures torn from magazines (called "scrap"). A friend peers over his shoulder.

"That's *good*." Then there's a pause. "I wish I could draw." Another pause. Then, sadly: "I can't even draw a straight line."

The cartoonist smiles, because he's not so hot at drawing straight lines himself, even with a ruling pen. That he doesn't like straight lines, doesn't want to be bothered with them, finds them a chore—this helps explain why he's doing cartoons rather than, say, architectural drawings. Here's a guy who's informal. Having fun. He may not be up to straight lines, but he can draw recognizable figures and objects; he knows a little bit about lettering; he knows some principles of design; he understands the process of reproducing artwork; and he has a few ideas and a willingness—a compulsion—to spend countless hours developing those ideas into salable finished drawings.

He does not bother to confess his own shortcomings in the straight-line department, but he does tell his onlooker: "Sure you can draw. Anybody can draw."

His remark is both fraudulent and sincere. He's sure the onlooker will never be able to approach *his* level of ability (not

even the big-name cartoonists are able to accomplish that!), but he knows the onlooker could develop a certain amount of basic skill—enough to amuse the children and decorate outgoing letters, at least.

It's true that some people are born with high talent for drawing. They're naturally artistic. But it is also true that far less talented persons, who have an interest in art, can, with a little outside help, learn to draw, too.

It is the purpose of this book to provide the outside help needed by beginning artists and to serve as a refresher course for persons who long ago abandoned the idea of producing straight lines and instead directed their attention to the much more interesting field of cartooning.

The Art of Cartooning

1

The Development of the Cartoon

What is a cartoon?

One dictionary says it's a "sketchy picture or caricature . . . intended to affect public opinion." This is a good description of an editorial or political cartoon and, perhaps, a cartoon for an advertiser; our definition, however, should be expanded to include mention of humorous drawings—comic strips, gag cartoons and spot drawings—which have the less ambitious function of simply entertaining.

And what kind of people draw cartoons?

Let me tell you of my first meeting with Dan Mindolovich, who's been attached to a couple of newspapers in the Northwest.

New at Jefferson High School, Portland, I had signed up for a course in cartooning, a unique offering among high schools then. As I walked into the room, I saw in the back a dark-haired fellow, looking at a cartoon, laughing so hard that tears were running down his cheeks. I rushed back, had a look, and admitted, "That's pretty good, all right. Who did it?"

Dan could hardly control himself. "I did." And he was off again.

Virgil (Vip) Partch, that zany cartoonist from Capistrano Beach, California, comes from a "pretty serious family of artists." According to his own account, his forefathers were

"pretty square, and they were missionaries and didn't go in too much for *Playboy* or *Punch*."

"Then how did you get into the business of comic art?" I once asked him.

I was quite tall as a kid [he said] and my hands and feet were as big as they are now, but I only weighed about ten pounds, and with the cross-eyes and the odd build it was kind of hard to be serious. What really did it was, I was in a little grammar school and we had three rooms and we went all the way through the 12th grade, so each room had about four classes in it. I was in love with a girl who was a couple of years—three years—ahead of me, but she was a gorgeous creature (and to prove that point she became a feature dancer in Tiajuana when she grew up). I was chinning myself once and she was around there, kind of handling the little kids, and while I was chinning myself my belt broke and my pants fell down. Well, you just can't be dignified about a situation like that. I had to cover it up with a jolly old laugh and a little clowning, so I decided right then and there that I'd be a cartoonist. *

There's a little bit of clown in the typical cartoonist.

There's a good dose of seriousness, too.

The late Art Young once classified himself as a "Republican," anxious for fame, fond of fine clothes. But having tasted insecurity when he lost a job on the Chicago *Tribune*, felt shock on seeing the slums in Chicago and New York, come close to death from an illness while studying art in Paris, endured an unhappy marriage, wandered into socialist lectures to pass his evenings—Art Young gradually gave up his conservative ways. He developed an intense hatred for capitalism, war, slums, prudery and pay toilets, among other things. His work went mostly to nonpaying, radical magazines. To sustain himself, he occasionally sold to the general circulation magazines.

* "The Cartoonist As Human Being," *Northwest Review*, Fall-Winter, 1960. p. 57.

2

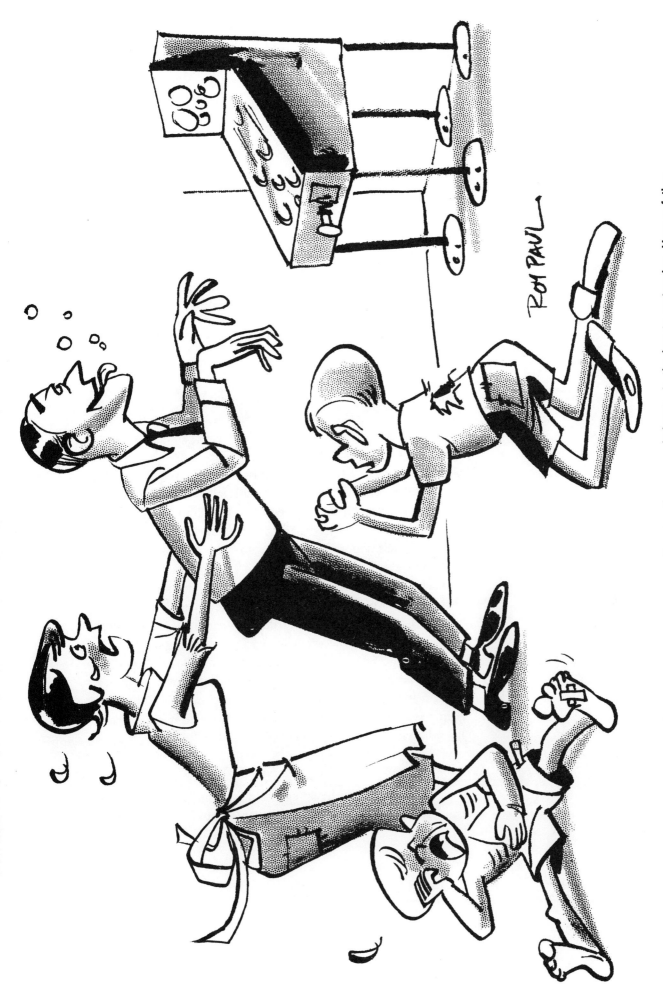

ROY PAUL

Exaggeration—or melodrama—is the key to cartooning. Here a father addicted to gambling is urged by his family to hold on to badly needed money.

But even in these cartoons there was some of the Art Young philosophy. Whenever he got paid for one it reminded him of the Irishman working in America, writing back home: "Jim, come on over. I'm tearing down a Protestant church and getting paid for it besides!"

Twice Young's work brought him into the courts: once when the Associated Press was aroused over his cartoon suggesting that estimable organization was poisoning the minds of its readers and once when the federal government decided Young was conspiring "to obstruct the recruiting and enlistment services of the United States." Both times Young was acquitted. During the second set of trials, with his life at stake, Young fell asleep in the courtroom! It was his way of showing his contempt for the system he was fighting.

Charles Schulz since 1950 has been charming a growing audience with that unlikely collection of kids in "Peanuts": Lucy, the world's champion fuss-budget who has in her library such volumes as *The Power of Positive Fussing* and *Great Fuss-Budgets of Our Time*; Linus, the boy who finds solace with a blanket; Schroeder, the young pianist who finds playing a Beethoven sonata very difficult indeed, especially when all the black keys are *painted* on the keyboard; and of course "Good Ol' Charlie Brown," who has finally come upon the reason nobody likes him: he's unpopular. Those who know Schulz personally know him as a deeply religious person whose reliance on prayer and whose dedication to his church have given him a security that Linus, with only his blanket, could never find. Those who study his strip—and it's worth studying—can detect a good deal of theology there. One strip showed Lucy bawling out Charlie Brown for getting all the answers wrong at school. "I guess I sort of misinterpreted things," said Charlie Brown. "I didn't think being right mattered as long as I was sincere!" Billy Graham was so impressed with that one he reprinted it in *Decision*, his otherwise cartoonless magazine.

THE FIRST CARTOONISTS

Cartoon scholars have suggested that the great French artist, Honoré Daumier, is the "Father of Modern Caricature"

("caricature" being a term at one time synonymous with "cartooning"). In England, working in the 1700's, the genius painter and engraver, William Hogarth, earned a reputation as a satirist through his drawings and engravings. In our country, Benjamin Franklin (who else?) is thought of as our first cartoonist (you remember his 1754 "Join or Die" cartoon reproduced in the history books).

These early cartoonists were a grim bunch. They had a job to do, evils to correct, countries to educate. The laughs were to come later.

The first big name among full-time American cartoonists was serious-minded Thomas Nast. A widely circulated magazine, *Harper's Weekly*, gave Nast an enthusiastic audience during the Civil War and afterward. Nast was a strong advo-

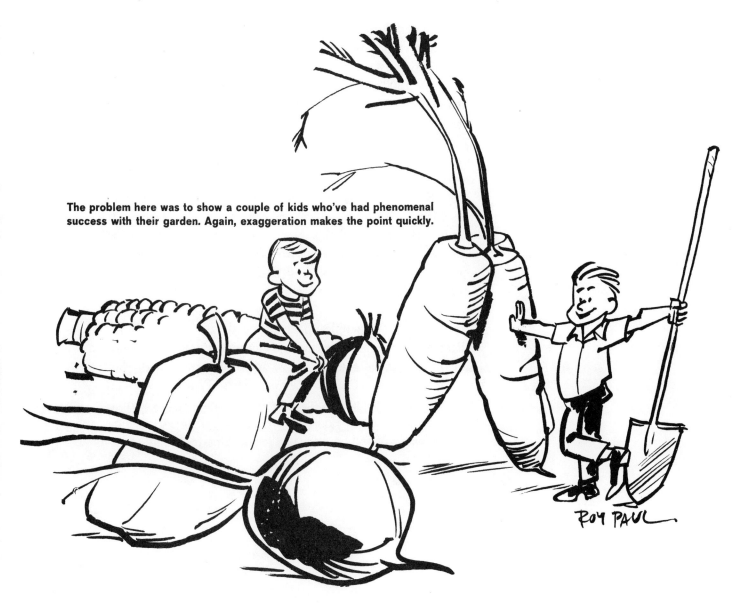

The problem here was to show a couple of kids who've had phenomenal success with their garden. Again, exaggeration makes the point quickly.

cate of the cause of the North, a steadfast admirer of U. S. Grant, an unwavering critic of Horace Greeley. A Republican, he is credited with having invented the elephant symbol for the party and reviving the donkey symbol (some say he invented it) for the Democrats. The tiger, which stood for Tammany Hall, was another Nast idea. Nast had a mania about Tammany; within a few years he turned out some fifty cartoons against Democrat "Boss" Tweed, who apparently feared the cartoons more than any of the articles attacking his corrupt city administration. So accurate were his caricatures of Tweed that the politician, after he fled to Spain, was picked up by police there who recognized him from Nast's drawings.

THE CARTOON'S INFLUENCE

The cartoon's power to influence public opinion probably has dwindled during our century. Students who go back to the political cartoons of the last century are surprised to see how much more outspoken generally the cartoonists were then than now. The 1800's were the era of "personal journalism" when cartoonists and their editors were more inclined to be bitterly one-sided. They were less inclined to worry about mass circulation or mass readership. They were not afraid to offend minority groups or even large groups of readers. Take the obit cartoon by Joseph Keppler upon the death of the Mormon leader Brigham Young. It showed a row of women in bed, crying, with a wreath hung from the center of the bedboard. Or consider Bernhard Gillam's cruel portrayal of James G. Blaine as a man unveiled, with all his past sins tattooed over his body, one of a series that, according to Roger Butterfield in *The American Past*, "played an important part in wrecking Blaine's Presidential hopes."

Not that the people under attack always laughed it off. Blaine considered prosecuting the editor of *Puck*, which published the tattooed man cartoons, on an obscenity charge but then reconsidered. There was a governor in Pennsylvania who got so upset over his administrators' being pictured as various kinds of animals that he rammed through a law in 1903 making "animalizing" of public officials illegal. A cartoonist in Phila-

delphia promptly drew a cartoon showing each official as some kind of vegetable. The law soon died.

Libel laws, generally, were less strict in those days. Most cartoonists working for newspapers, syndicates or magazines today, I think, would like to have operated during that uninhibited era.

Freedom to be one-sided was only part of the story. There was less distraction from other journalistic media then. The cartoon-carrying newspapers and magazines had no competition from radio, television or the movies; the editorial cartoon was an item to be studied and to be talked about.

This meant that the cartoonist of the 1800's could produce a more complicated drawing. He made wide use of crosshatches. There was a great deal of detail. The "balloons" above the characters' heads were filled with much type of a small size.

After the Civil War cartoonists were signing their names to their drawings and earning a great deal of notoriety. They were still working, principally, for magazines. It wasn't until the newspaper circulation battles of the 1890's that cartoonists, in any appreciable numbers, found jobs on newspapers. The newspapers not only appropriated the idea of editorial cartoons from the magazines and hired away the cartoonists; they also borrowed the idea of printing in colors. The Sunday comic supplements were born during this period.

Moving from magazines to newspapers was quite a change for a cartoonist. In the first place, he had to adjust his approach. The cartoon ideas had been based often on Greek mythology, or on Shakespeare, or on other classics made analogous to situations in Congress or in the administration. But newspapers were becoming preoccupied with "the average reader," and this meant their cartoons had to be understood by such a reader.

A more serious problem faced the cartoonist on a newspaper: frequent deadlines. Cartoons had to be produced every day.

A NEW EMPHASIS

At the turn of the century, a new type of cartoon—the comic strip—was developed. Assigned an entertainment func-

tion rather than an opinion-making function, the comic strip was part of the publishers' plans to build huge circulations. The era of personal journalism was passing. The era of mass communications was here.

The earliest comic strips, too, had a great deal more sting than those of today. It was ribald art, peculiarly American. Some of the earliest of the comic strip or humorous panel artists were F. Opper, also an editorial cartoonist, whom art Critic Thomas Craven calls "the funniest man ever connected with the American press," Eugene Zimmerman and T. A. (Tad) Dorgan. Craven, in *Cartoon Cavalcade* (Simon and Schuster, New York, 1943), reprints a number of these men. So does Coulton Waugh in *The Comics* (The Macmillan Company, New York, 1946) and Stephen Becker in *Comic Art in America* (Simon and Schuster, New York, 1959). You'll want to get acquainted with these books. Your librarian can help you find books which show the work of the early political artists. One good one is Allan Nevins' and Frank Weitenkampf's *A Century of Political Cartoons* (Charles Scribner's Sons, New York, 1944). In bound newspaper files in the library you'll find the work of the first rollicking comic artists as originally printed. If you haven't seen "Indoor Sports," or "The Yellow Kid," or the *early* "Katzenjammer Kids" and "Mutt and Jeff," or "Happy Hooligan," or "Alphonse and Gaston," or "Abie the Agent," or "Polly and Her Pals," or "Toonerville Trolly" or "Krazy Kat," you're in for a most rewarding experience.

The one-line (or more correctly, one-quotation) gag cartoon is the newest of the print-media cartoon forms. Prior to the 1920's, entertainment cartoons in the magazines had been nothing more than illustrated jokes of the "he:she:he:" variety. Now, nearly every magazine running cartoons has cut down on the caption and added impact to the drawing. And of course there are no "balloons" of conversation inside the drawing. What printed matter there is, is confined to one or two sentences, all spoken by the same character (the one with his mouth open in the cartoon). A fairly recent trend is the omission of a gag line altogether. The picture tells the entire story.

2

Tools and Techniques

You're ready to begin drawing.

You have a corner somewhere, by a window, preferably on the north side of the house for a steady, even light. Ideally you have a drawing table; if not, you have a drawing board to prop against a table. You'll have some sort of a lamp for night work. There should be another small table—a taboret—nearby on which you can keep your supplies.

Here's what you need:

Paper.	Construction paper, detail paper, or a good bond paper is all right; Bristol board or illustration board is better. Stathmore is excellent. A rough texture for pencil and brush, a smooth texture for pen.
Pencils.	An HB, B and 2B (hard, medium and soft) to start. You'll need a blue one too.
Pens.	Gillott 170, 290 and 404 (fine, flexible fine, and coarse) will give you a good range of drawing pens. Several Speedballs in the "C" and "D" series will come in handy for any lettering you'll do.
Penholders.	One will do. You'll appreciate a half a dozen.
Brushes.	Red sable; Nos. 1 and 4 to start.
Ink.	Black, India.

Lampblack.	A tube. For wash drawings.
Chinese white.	A tube. Or a jar of white poster paint. For making corrections.
Erasers.	Art gum and soft rubber. Maybe even one for ink.
Rubber cement.	Small jar.
Masking tape.	For fastening your work to the board.
Ruler.	
T-square.	
Triangles.	At least a 30-60. A 45 would be useful too.
Ruling pen.	
Razor blades.	Single edge. For sharpening pencils, scratching away errors, working on scratch-board drawings, etc.
Scissors.	One pair. A paper cutter would be better.

Perhaps you can get along without some of these items, but I'd say this is a pretty basic list. Certainly you can—and probably will—add to it. Of course, you'll need some boxes and jars to keep your supplies in. As you get more involved in cartooning, you'll begin to haunt the local art store to keep abreast of new materials on the market. If you have no art store nearby, you can shop by mail, through the catalogue issued by Arthur Brown & Bro., Inc., New York, or some similar art supply firm. A perusal of magazines like *American Artist* will interest you, too.

HANDLING YOUR TOOLS

Most cartoonists rough in their drawings first in pencil, then trace over the lines with ink, using a pen or brush. Some, who don't want to be bothered erasing pencil lines afterward, do the preliminary work with a blue pencil. Blue, provided it is light enough, does not reproduce under ordinary printing procedures.

You should always draw the pen toward you, or from left to right. Don't try pushing it away from you. The point will dig into the paper, sputtering ink as it falters. Don't dip the pen

too deeply into the ink. Try different points on different papers until you find a combination that pleases you, that seems to fit your style. As exercises, you'll want to dash off a series of long parallel lines, then a series of short choppy ones, then a series of crosshatches (lines running over each other in opposite directions). You'll want to experiment with all kinds of patterns that can be made with a pen.

With a brush you have considerably more freedom; you can race in any direction. And the faster you work, the more satisfying the result can be. This tool is made for "loose" handling. You'll probably want a scrap of paper nearby on which you can "roll" out the point each time you dip it into the ink.

It is imperative to wipe clean a pen point and to wash out, with cold or lukewarm water and soap, a brush immediately after use. I buy only the very highest quality brushes, because the point they hold is all-important to me; but through proper care I give a brush a long life.

After you have mastered one tool or after you have used one type of paper many times, make it a point to switch to something new. You'll make many exciting discoveries as you go along.

For many years, the only drawing tool I used was a Gillott 170 pen on Bristol board. Reluctantly, I picked up a brush one day to try to produce a drawing with a heavier feel. It was tricky to handle. I almost decided to give it up. But today I use a brush—a No. 0 or 1—almost exclusively, and on any kind of paper, including printer's cover stock, typing paper and even paper towels.

Occasionally, a cartoonist wants a "different" effect. I was in this kind of a mood when I decided to use a matchstick dipped in ink for some of the heads reprinted in Chapter 5. Byron Ferris, Portland, Oregon, a commercial artist, recently had the job of depicting the bark of a tree. He obtained his effect by inking, with a brayer, a piece of real bark and pressing it against a sheet of paper. A cartoonist, Jack Lambert, who worked for the Chicago *Sun*, used to do editorial cartoons in *clay*, photograph them, and then turn the photograph over to

the engraver for a halftone reproduction. The effect of my spot illustration reproduced here could hardly be obtained as a conventional drawing; I simply cut out pieces of colored paper and pasted them down for halftone reproduction.

In experimentation lies much of the fun of cartooning.

A $1.25 investment in S. Ralph Maurello's paperback *Commercial Art Techniques* (Tudor Publishing Company, New York, 1952) will fill you in on the multitude of techniques I don't have space to go into in this volume.

DRAWING FOR REPRODUCTION

The desire of most cartoonists is to be published. For a cartoon to be published means that it must be reproduced many times, and the reproduced version should be as clear and sharp as the original. The cartoonist, then, in using the various

materials available to him must keep in mind always this question: how will the drawing reproduce?

Basically, there are two ways a drawing may be reproduced: line and halftone. A line reproduction shows only solid blacks and whites. A halftone reproduction, on the other hand, shows various shades of gray.

LINE REPRODUCTION. Perhaps I've overstated the difference. It *is* possible, in a line drawing, to get the effect of gray through the use of such techniques as these:

1. A series of thin, parallel lines, drawn or ruled close together.
2. Crosshatching.
3. Dots set down with a pen.

Other gray effects are obtained in a line drawing through the application, by the artist, of a sheet of Cellophane (Zip-A-Tone is one brand) on which is printed a pattern of dots or lines. The sheet is waxed on one side. The waxed side is pressed against the drawing, causing the sheet to stick, and a knife or razor blade is used to cut the Cellophane away from that portion of the drawing that doesn't require the pattern.

Another way to get the same effect is to use a specially treated drawing paper called Craftint. The paper carries a built-in pattern, in one or two tones, which shows through only when a chemical solution, which comes with the paper, is applied. The advantage of this process over the one described in the paragraph above is that you can get more intricate in the application of the pattern. A brush is more maneuverable than a razor blade.

A mechanical pattern can also be applied by the engraver (the Ben Day process). The artist simply shades in, with a light blue pencil, that portion of the drawing where a pattern should go. The blue will not reproduce, but it will serve as an effective guide to the engraver.

There are still other possibilities. If the drawing has been done on a rough-textured paper, a grease or lithographic crayon may be used for shading. This is a process used extensively by editorial cartoonists. The grease from the crayon, a very black black, sticks only to the top surfaces of the paper

or board, leaving white specks between those top surfaces. This creates a pattern. Among drawing papers there are a number of patterns, including dots, which are available. Coquille, Ross and Glarco are some brand names. Ordinary illustration board also works. A similar effect occurs when a brush, carrying ink, is allowed to "dry out" while drawing.

HALFTONE REPRODUCTION. When the grays of a drawing are more subtle—when they are smeared or blended—a halftone reproduction is required. A halftone is characterized by a pattern, sometimes barely discernible, of dots over the entire area. A special type of halftone, called a highlight halftone, succeeds in dropping out the dots in those areas which should be completely white.

Why the dots? In the reproductive process, of course, artwork must be photographed onto a film which in turn is used to expose a metal plate. The plate is bathed in an acid solution, and the areas which were white on the original drawing are "eaten" away, leaving only black areas standing. The standing areas are inked, pressed to the paper, and the reproduction occurs. This very rough explanation of the reproductive process should suggest to you that a gray tone would either have to be left as black or disappear altogether. Hence, in making a halftone, the engraver uses a screen to break the grays down into a series of dots. An area with well-developed dots is a dark area; an area with weaker dots is lighter. Technically, there are no solid blacks in an ordinary halftone.

It should be noted that *any kind* of a drawing can be reproduced halftone but *not every kind* of a drawing can be reproduced by line. A blended pencil drawing or a wash drawing (with shading achieved through the use of diluted India ink or watered lampblack), for instance, must go halftone. Comic strips and editorial cartoons are almost always reproduced by line; *some* gag cartoons, in the slick paper magazines, are halftones, but many of these, too, are line.

Many cartoonists prefer line reproduction because they can more adequately control the quality of the reproduction. So much is left to the engraver in a halftone. The big attraction of halftone reproduction to the cartoonist is the photographic effect he achieves. A cartoonist like Charles Addams, for instance, or Peter Arno, loses much of his effect in a line drawing.

One last point before moving away from this rather technical subject: the principles of halftone and line reproduction hold for any type of printing process. Basically, I have been

talking about letterpress printing (examples: newspapers, most books, and magazines like the *Saturday Evening Post*), but in offset lithography (example: this book), while the printer does not have engravings to contend with, he does have to photograph the artwork and he does have to introduce a screen when the drawing is done in true grays.

INSURING GOOD REPRODUCTION

The cartoon is often drawn larger than it is to appear in print. This is because in reduction many irregularities of line will disappear.

All lines and tones should be strong, clear, clean, crisp. Beginning cartoonists often make lines too close together (these fill in, in reproduction) or too light and weak (these drop out completely). Better to err on the side of boldness.

All pencil lines left over must be removed. Otherwise they may be picked up by the engraver's or lithographer's camera. There should be no smudges. There should be a margin around the drawing for handling purposes.

No drawing should be folded.

MAKING CORRECTIONS

You have these methods of correcting mistakes you've made with your pen or brush:

1. Painting over them with Chinese white or white poster paint.

2. Scratching them out with a coarse eraser or knife or razor blade. (The scratching process was much in use by cartoonists years ago. T. S. Sullivant was particularly busy cleaning up mistakes after each drawing. Commented F. Opper: "if Sullivant would scratch his head more and his paper less, he could draw better cartoons").

3. Pasting a piece of paper over the messed-up part of the drawing and redrawing that part, getting lines to fit into existing lines. (This works perfectly well for line drawings; it could cause some trouble in halftones, because of the shadow the extra thickness of paper might throw).

16

Pen drawing above and brush drawing below. Both are line reproductions. "Color" is achieved above with pen lines, solid black, and Zip-A-Tone; below by crayon on Glarco board, and solid black.

Scratchboard drawing. Line reproduction.

Wash drawing. Halftone reproduction.

17

TOOLS AND TECHNIQUES

WORKING WITH COLOR

If you want to sell your work, don't do it in color. It's too expensive to reproduce.

When editors want color in cartoons, they usually want *spot* color, black and one additional color. The color should be provided by the artist on a separate sheet, in regular black ink. First he makes his basic drawing. Then he attaches a transparent sheet of frosted acetate over it, and where he wants color he fills in with ink (a special and thicker ink is required). The two drawings must be in perfect register. Several register marks (X's or plus marks) on the acetate are superimposed over identical marks on the original drawing as an aid to the printer. He'll shave them off before printing.

YOUR APPROACH TO DRAWING

There are three basic styles used by cartoonists. These are: realistic, stylized, loose. Each has its place. Some cartoonists produce work in all three styles or in two of them. Others specialize. I suppose my work would be most closely identified with the loose school. At least, it's the one I most enjoy.

The realists can be found most readily among the creators of adventure strips, the stylists among those who work for advertisers, the loose workers (I was going to say loosers) among the gag cartoonists, but there is much overlapping.

You should experiment with all three styles.

If you tend toward realism you'll appreciate the work of Milton Caniff and the late Alex Raymond; if toward stylized handling, the work of, let's say, Doug Anderson (he has an excellent book treating the subject called *How to Draw with the Light Touch*, Sterling Publishing Co., Inc., New York, 1954) and Roy Doty; if toward looseness, the work of Lichty (George Lichtenstein) or Roy McKie or Barney Tobey. (I was just thinking of the wonderful detailed but better than realistic work of gag cartoonist George Price and wondering where I'd place him; I suppose he's of the stylized school).

Whatever your preference, you'll benefit from study of the fine arts, from which cartooning has sprung. You can best

exaggerate in graphics when you first understand basic art principles.

As you draw, try to sculpture rather than outline. Try to feel the solidity of what you put down on the page. In your roughing-in phase, work out the basic construction of each item you draw.

It might help to think of all shapes as falling into these basic forms: the cube (houses, books), the cylinder (arms, legs, tree trunks), the sphere (balls, globes), the cone (treetops, mountains). Cut the cube diagonally through the center and you have a roof top, cut the cylinder in half and you have a Quonset hut, cut the sphere in half and you have a bowl.

It's good to settle early on the basic shape of each item you draw.

"I'M BEGINNING TO WONDER IF YOU'LL EVER BECOME AN ARTIST"

3

The Figure

A group of artists, three or four who made a living at it and three or four who just liked to draw, used to get together in my home town every two weeks for what they called, loosely, a "sketch class." There was no teacher. But there was a model, a girl in a bathing suit who collected a total of four dollars for the evening. For a little less than the price of seeing a movie, these artists were able to exercise their drawing skill, sharpen their eye, improve their technique. The professional artists in the crowd welcomed the sessions because their working day was spent, mostly, pasting up Artype or drawing buildings with a ruling pen or designing logotypes for retail firms. The "life" drawing kept them in trim for the occasional spot illustration or cartoon drawings they were called on to make (a nonmetropolitan commercial artist must be a semi-expert in every phase of art). The amateurs in the crowd welcomed the sessions because there was a discipline there: they *had* to draw for a two-hour stretch. And they derived some inspiration from the professionals around them.

The class has temporarily bogged down. Some of the artists moved away. Maybe the model got married. I don't remember. But it'll start up again. And others will start up—and are now operating—all over the country. Perhaps you'll want to start one in your home town, or if you live in a community

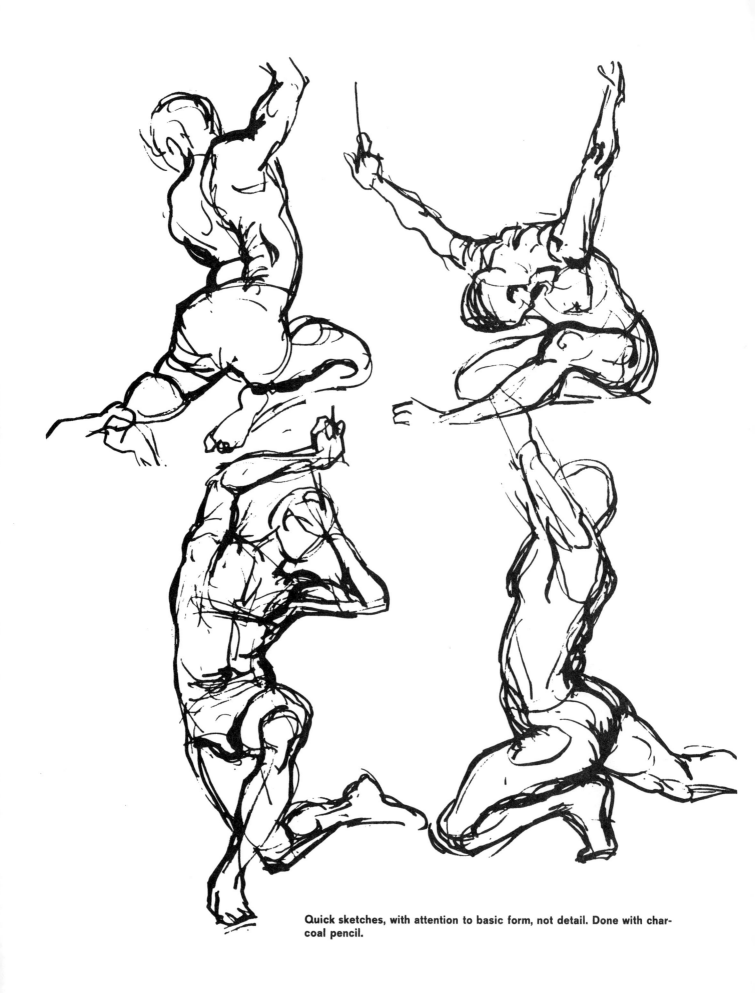

Quick sketches, with attention to basic form, not detail. Done with charcoal pencil.

where there is a university or an art school, you'll want to sign up for a supervised course in sketching.

The focal point for these classes is the human figure, often unadorned. And for this reason: every conceivable problem —light and shade, form, composition, proportion, foreshortening—must be solved by the artist as he tries to transfer the three-dimensional model to his two-dimensional drawing surface. Sketching a live model is the best possible practice for an artist and, yes, for a cartoonist, too. Even after he's well along on a career, the cartoonist first sketches in the body, then fits the clothes on and around it.

Let me encourage you to concentrate, even at the beginning, on quick sketches. Your model, if you have a formal arrangement, could be encouraged to hold each pose for two, three or five minutes only. There should be hints of action— body bent forward, twisted, one leg up on a chair, perhaps— but the poses should be natural ones. Sometimes the model should sit, sometimes stand, sometimes lie down. Don't worry about your angle of vision. And don't worry about details. Start out with stick drawings. Add major details quickly, lightly, going back as you have time to fill in. Try to consider the drawing as a mass rather than as an outline. Draw as though you were molding the model in clay.

My emphasis here on quick sketches should suggest to you that you don't even need a model who is aware he or she is posing for you. Seated inconspicuously in public places—on the fringe of a swimming pool, in a bus depot, at the beach, at a baseball game—you can, with broad strokes, draw the people around you.

Sound advice, which has been given many times before by many persons who write how-to-do-it books in this field, is that you carry a small sketch pad with you wherever you go, and that, when waiting in lines or in offices or for buses, you use your time to advantage. Don't worry about the details of clothing at first. Don't become involved with wrinkles in the cloth, or the texture of the material. Keep your drawings simple.

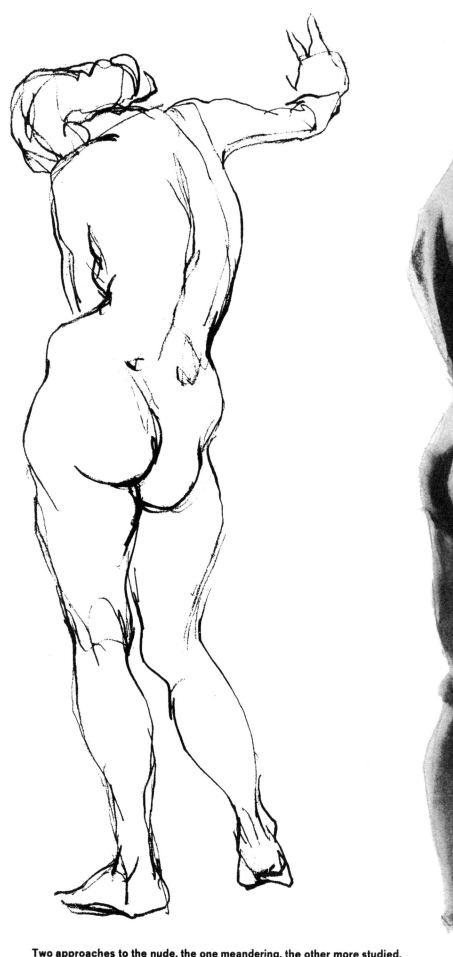

Two approaches to the nude, the one meandering, the other more studied,
with attention to lighting.

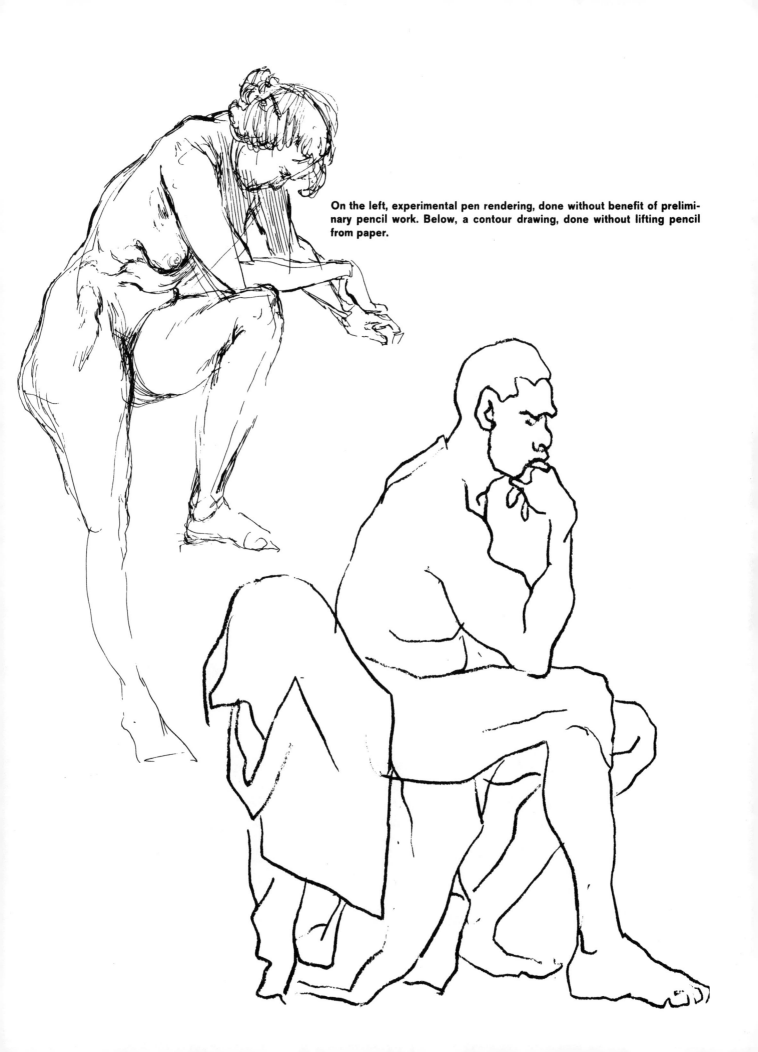

On the left, experimental pen rendering, done without benefit of preliminary pencil work. Below, a contour drawing, done without lifting pencil from paper.

Additional practice may be had through the use of magazines. Get into the habit of copying photographs which have been reproduced in the editorial part of the magazine or in the advertisements. *Do not copy paintings or drawings*, or at least do not make a habit of it. What you are doing is researching into the way the body is put together and the way its various parts move, not into the drawing techniques of other artists. A limited amount of copying of the work of other artists can be helpful, of course, but it is too easy to fall into the habit of using their work as a crutch. A look at the current crop of gag cartoons in the national magazines should convince you that copying of other cartoonists' styles is much overdone. It is hard to tell whose style belongs to whom. I think you'll be much more pleased with your output of cartoons if you know they represent a style that is truly yours.

I would like to suggest—although we won't have time to do much about it formally in this book—that you spend some time studying anatomy, what *really* lies beneath the figure you are studying. There are many books that cover this topic. An old standby is J. H. Vanderpoel's *The Human Figure* (Bridgman Publishers, Inc., Pelham, N. Y., 1935).

PROPORTION

Bear in mind, as you draw, that the human figure varies between seven and eight heads in height. The smaller the head, the taller your figure will appear.

Learn to use parts of the body as units of measurement. Look at the model before you. The distance between the shoulder and the finger tip (in a normal standing pose as seen from a normal eye level) is almost the same as the distance from the hip to the toe. Does your drawing reflect this? The model's shoulders are more than twice as wide as his head. And so on. You'll develop your own scale of measurements as you go along. And they'll change from pose to pose.

Where your model takes a twisting pose, note the slope of the shoulders and hips. If one shoulder is up, the hip on the same side dips lower than the hip on the other side.

FORESHORTENING

If sketching from life is new to you, your biggest problem, undoubtedly, will be foreshortening. Basically, foreshortening means this: when one part of the body is closer to you than another part (say, an arm is extended toward you), that part is enlarged in the drawing. And of course, part of the arm, the part nearest the shoulder, is hidden, or partially hidden. The arm appears "shorter" than it really is. This is the only way you can achieve the three-dimensional effect you need.

You can first reduce the arms and legs to cylinders in order to better handle the problem of foreshortening. Incidentally, the main sections of the body (the head, the chest, the pelvis) sometimes need to be foreshortened, too.

THE CARTOONIST'S APPROACH

Assuming that you have gained some insight into basic drawing principles, and that you will, as you progress in your work, take the time to do some really serious drawing, I'd like to move on, now, to the cartoonist's approach to the human figure.

While the artist of the Realistic School is careful to put down on paper people who look like people, with arms just the right length, with the head just the right size, with the muscles bulging in the right places, the cartoonist goes out of his way to distort the figure and its parts. Is his figure seven or eight heads high? If you've studied the comic strips or gag cartoons you know the answer is "No." A cartoon figure is much less than seven or eight heads high. It is three or four or five heads high, in many cases. Why? An oversized head gives the cartoonist room to dramatize the all-important facial expression upon which, in many cases, his idea is dependent. In realistic drawing, the head is divided, in effect, into two halves, with the eyes on a line that runs right through the center of the oval. Cartoon heads, on the other hand, have eyes well above the center line. Why? Perhaps the reason is that the cartoonist hates to waste all that space on a nondescript forehead.

Nor is the cartoonist content with these nonconformities.

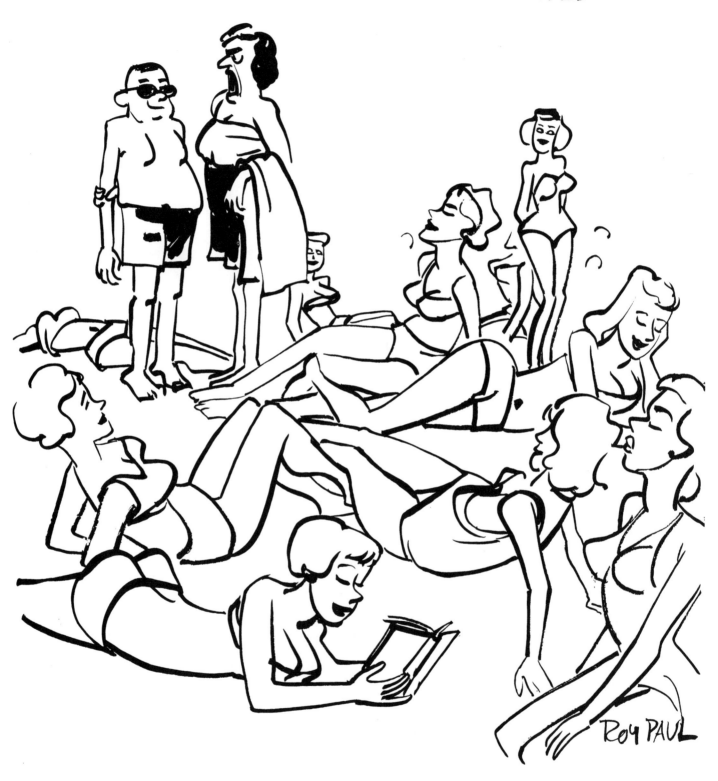

The size of every feature is exaggerated. Noses are bulbous. Eyes are bugged. Hands are oversize and, except for pretty girls, so are feet. In the cartoonist's world, a girl with a pretty face invariably has an abnormal chest condition. In recent years there has been a strong tendency among cartoonists to de-chin their men. Except for the handsome, athletic types, the man's face below the mouth slides down into the chest with no sweep inward for a chin or neck.

ACTION

The mark of a good cartoonist is his ability to get action into a picture showing an unheated conversation between two standing and/or seated persons. There's no trick to get action into a running or falling figure. But action in a picture centered around an ordinary conversation—there's a challenge.

Perhaps the patron saint of action among the comic strippers is Roy Crane, who years ago started syndicating his "Wash Tubbs" and who now does the strip "Buz Sawyer." Crane can take any situation and work excitement into it. He is unquestionably one of the greatest artists in the business.

Take a situation involving two businessmen talking. They can be standing, facing each other, with hands at their sides. That's a perfectly normal setting, and passable when it shows up in cartoon form. But how much more interesting your drawing is when you have one of the men standing on one leg, with one hip thrown out, perhaps with one hand in his pocket. The other figure could be half-sitting on a desk. At least, he could be leaning over a little as he talks, using his hands to make a point. It is important, as you develop a scene like this, to work up some contrast between the two men; don't allow both to take the same pose. And let one overlap the other.

What about the scene in which action is inherent? Take a running figure. He leans forward. His hair and coat tail, due to the wind he generates, fly toward the rear. If the right leg is forward, the right arm is bent toward the back. It's important to lift him off the ground. This is done by placing a shadow some distance underneath him—well below his feet. Additional speed can be indicated by clenched fists; sweat drops flying to the rear of his head; horizontal, parallel speed lines, culminating

in little puffs of smoke. If your figure is running, make him *really* running. If she is frightened, make her *really* frightened.

Often when you want to suggest action, you'll show your figure off balance. But when he has at least one foot solidly on the ground, you must put him in balance. Establish your point

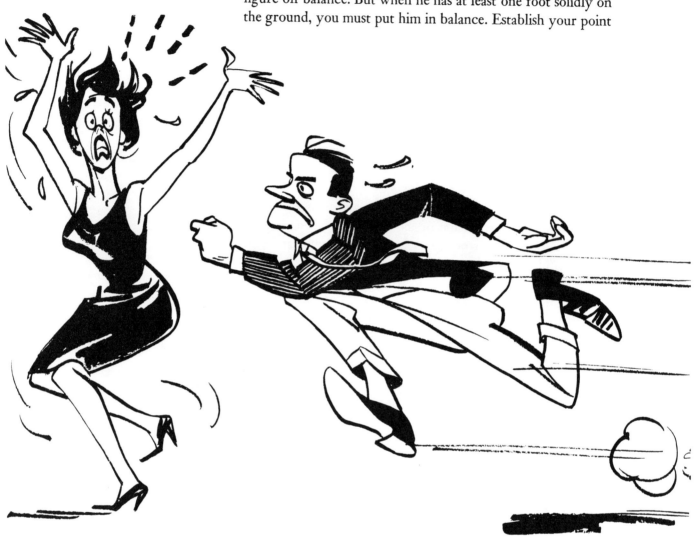

of support—it may be at that foot or somewhere between the two feet—send a vertical line up from that point (for your own information), and make sure half of him (by weight) is on one side, half on the other. If he's carrying something, that should

be added to the body weight and credited to the side it's on. Take into account the effect—the strain—on the body brought on by what's being carried. Make your reader *feel* it.

CLOTHING

Don't be a square about clothing. Keep up to date. If pointed shoes are in, put them on your characters. When you have a teen-ager to draw, deck him out in the latest.

Show texture when it will not get in the way of your main idea. If it's wool, give it a heavy, thick feeling. If it's silk, let it hang limp. Put your pen to work with the shadings you practiced in Chapter 2. If there's a pattern, let the pattern follow the contour of the clothing instead of allowing it to spread out flat (unless you're doing a stylized drawing). If a man is wearing a dark suit, don't be afraid to fill it in solid black. If you have him arranged in an interesting silhouette, you don't have to worry about outlining his sleeves in white to set them off against the coat itself. Forget the knickknacks—the belt loops, the buttons, the stitching—unless there's a reason to emphasize them.

Fit the clothing *around* the figure. Work out his form first.

FOLDS IN THE CLOTH

I think I can simplify this problem by suggesting that the cartoonist has two kinds of folds at his disposal:

1. Tense folds, caused by a stretching of the cloth, say at the knees, seat, across the shoulder. These folds should be drawn pretty much in straight lines. They'll be prominent in the clothes of fat people.

2. Relaxed folds, occurring, for instance, in back of the knee, where excess cloth bundles over when the leg is bent; at the crotch, when a figure is seated; at the front of the elbow. These are either angular or curved, often short, and can be numerous. Thin folks have a wealth of these folds.

Each time you draw a fold, make a choice as to whether it should be a tense fold or a relaxed fold.

It is easy to overdo folds. I think George Wunder in his

"Terry and the Pirates" is too devoted to them. Folds can easily clutter a cartoon drawing. Gag cartoonists and others who must keep their work particularly simple have solved the problem of folds by largely—and I think rightly—ignoring them.

34

Some wrinkles in clothing are relaxed, others are tense. It's easy to over-do wrinkles in a cartoon.

As the cartoonist moves away from realism, he almost eliminates wrinkles.

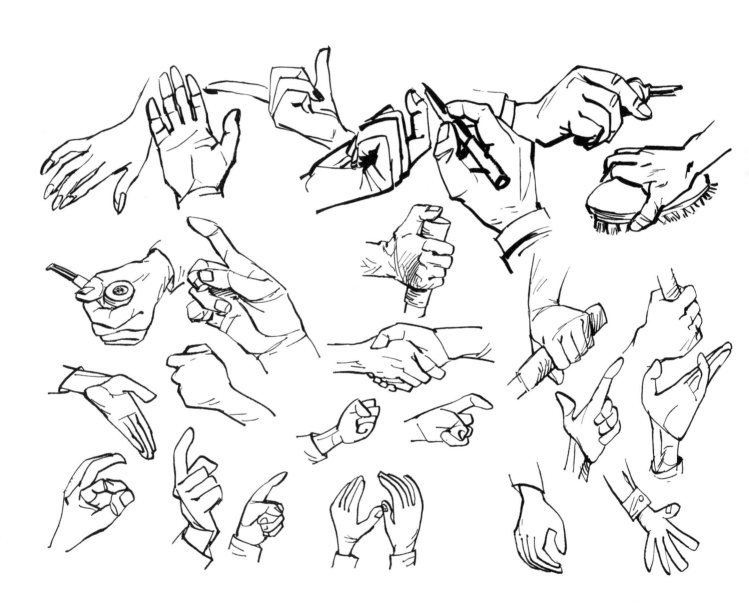

4

Hands and Feet

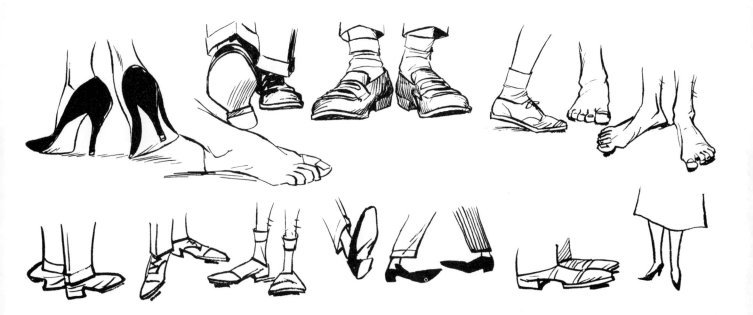

There was this little cartoon character. A piece of a log, with twigs to represent his arms and legs. A Mickey Mouse expression on his face. It had represented one of our large industries for years and years. My job was to do a series of rough layouts, working the little character in wherever I could. The series then went out in rough form for approval of an advertising advisory board.

Then came that angry letter in response.

One of the reviewers was upset. Not about the ads themselves. They were all right. But that cartoon character. "Whoever heard of people with only three fingers on their hands!" was the theme of the complaint.

That the little character had been romping through the industry's advertising for some years underfingered; that he was anything but real anyway—this apparently did not occur to the executive. Why he didn't complain about the twig arms or the log body, too, has remained a mystery to me. He just happened to be a finger-counter and he didn't like what he saw. His credulity in that department had been outraged.

Someone with a public relations approach apparently smoothed it over, and as far as I know, the little three-fingered character still does his work for the free enterprise system. Certainly in the world of cartoons he's not out of place.

The executive who complained needed only to watch one of the cartoon comedies, or to inspect any one of the hundreds of cartoon symbols now in use, or to take a closer look at Mickey Mouse, Donald Duck or any of the Walt Disney characters to see that fewer than the full quota of fingers is "in" and has been for years. There's a reason: in animation, where it started, the fewer fingers, the less drawing to be done over and over, the fewer changes to be made from panel to panel. And there's some merit in doing away with detail; extra fingers are just so much extra baggage.

Then there's that other extreme, pioneered by Virgil Partch. "Vip's" view of hands is almost un-American: he draws the sleeve on a character, then absently begins making loops for fingers jutting out from underneath. If it happens to be a wide sleeve, well, there just might be six or seven or more fingers per hand.

On the issue of fingers, I tend to take the middle road. My hands are clean; the ones I draw are normal. But you suit yourself.

Long ago Bud Fisher (who originated Mutt and Jeff) discovered that hands could be simplified by putting gloves on them. So all of his characters, whether at the race track or at church, dancing or washing dishes—it didn't make any difference—wore gloves. The animators, working with animals, have found gloves help solve their problems, too.

Here are some things to remember about hands:

1. The length of the fingers (as a mass) is about the same as the length of the rest of the hand.

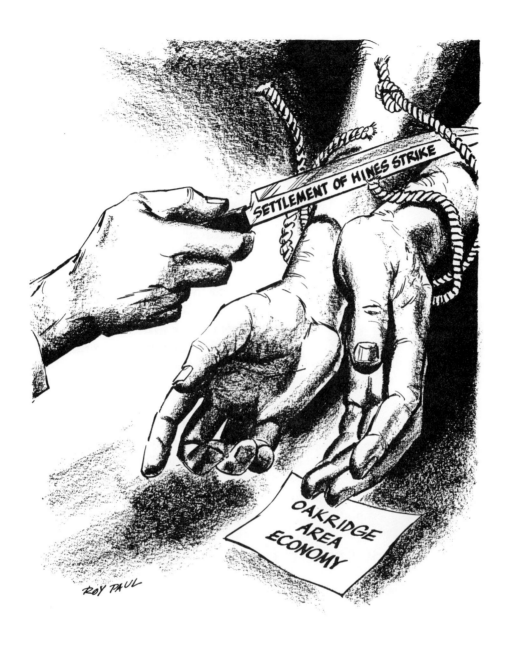

Editorial cartoonists often make use of closeups of hands to put over their ideas. Here a photo was referred to for detail. Drawn with brush and crayon.

2. The fingers, as a mass, taper at the end of the hand.

3. The fingers are of unequal length: index finger longest, other middle finger second, pointing finger third, little finger fourth.

4. The hand—especially the cartoon hand—is larger than the beginner usually draws it. With the heel of the hand placed against the tip of the chin, the fingers stretch almost to the tip of the forehead.

Your own hand can serve as your model, but you'd better use the one not holding the drawing pencil if you want to keep your sanity. A mirror will help convert that hand to its opposite number. (With writer Robert Paul Smith, I'm still puzzled over why the mirror reverses, right to left, but doesn't change top to bottom). For around five dollars you can buy a very realistic rubber hand, with a flexible wire core, which can serve as a tireless model. Cartoonist Jack Markow's suggestion that the beginner consider the hand as a mitten, using the thumb as one unit and the fingers as another, is a good one. You can sketch in each finger after you have the basic form roughed in.

The cartoonist finds the hands he draws are invaluable in adding to the expression of his characters. A finger pressed to the lips means silence, a clenched fist means anger and so on.

Feet are less of a problem because you can almost always cover with shoes your lack of knowledge of their construction. And in many of your cartoons, especially in comic strips, you'll crop off your figures before getting to the feet anyway. But you should remember this: the feet, both from the front and the side, are triangular in shape. In drawing the side view, remember that the foot does not project forward only; it projects backward slightly, too, at the heel.

When a character is standing, get his feet planted firmly on the ground. And make them big. Except for good-looking women. Here you'll make them ridiculously small.

Many a cartoonist's work can easily be identified by the style of shoes he draws. Confuse your fans. Change shoe styles from character to character. Don't fall into the habit of making every shoe the same. Let some be thick-soled, some ripple-soled, some run down at the heel, some untied, some loafer-styled.

"WE CAN'T GO ON THIS WAY, DONNA...."

Feet, no matter how you look at them, even on real live pretty girls who've painted their toenails, are funny. The cartoonist should be peculiarly committed to the assignment of eking out an additional laugh—introducing variety—at this point in his drawing.

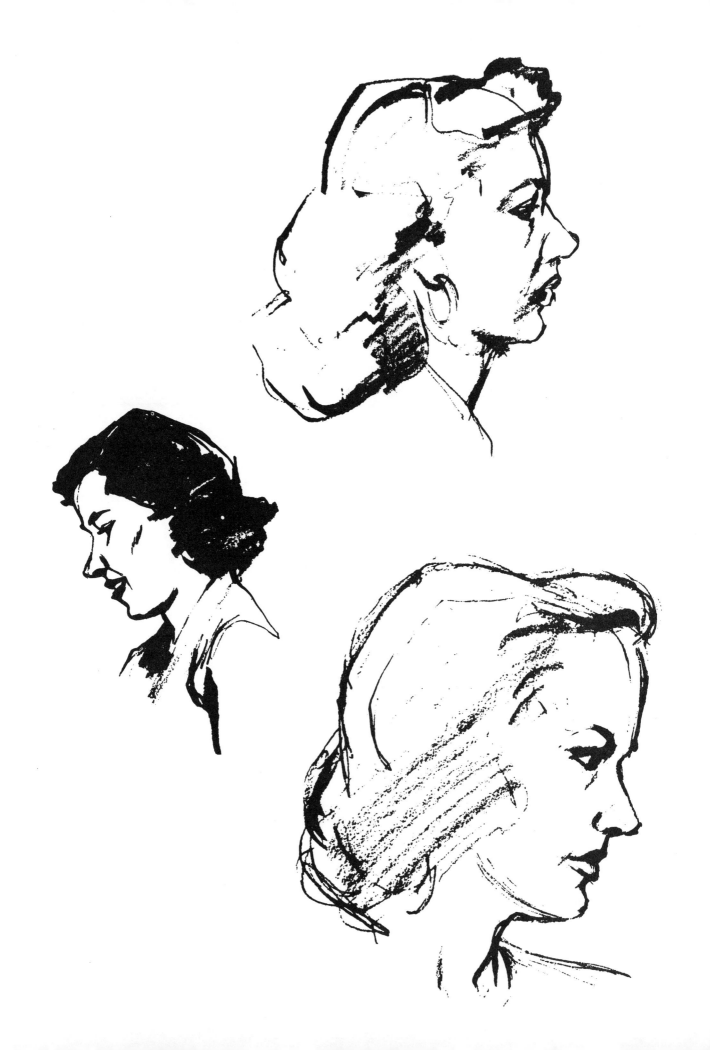

5

Heads and Faces

The local sketch class, mentioned in Chapter 3, might well concentrate on the head for a session or two. The head and the face, and the expressions on the face, are of utmost importance to the cartoonist. A cartoon's message is often wholly dependent upon a facial expression. The cartoonist distorts the size of the head, making it bigger than it really is, so that he has plenty of room to work in. He is thus assured that the expression on his cartoon character, magnified as it is, gets through to the onlooker.

A notable exception to the Big Heads School is the work of sports cartoonist Willard Mullin. Perhaps because he is more interested in action than in expression (although he is a master of both), he makes his heads even smaller than normal size. Fashion artists, too, minimize head sizes.

In figure drawing, the cartoonist is wise if he concentrates first on realistic handling so that he'll understand what he will eventually distort. In head drawing, too, the cartoonist should strive for realism at first. He should understand the basic structure of the head before he attempts to exaggerate the shape of the head and the facial features.

In drawing a cartoon figure, the cartoonist devotes most of his effort to whatever *action* is inherent in the pose; in drawing the head, he concentrates on the *expression*.

STRUCTURE

Let's consider the head itself, in its realistic state. The side view is easiest to draw. You start with an oval—the shape of an egg—widening it at the top and tilting it slightly, building as you go. Do not concentrate on any single feature until you have them all roughed in. The eyes, in a normal pose, are cone- or triangle-shaped, located about halfway down from the top of the head. The mouth in a side view is relatively short, almost never extending beyond a point just under the pupil of the eye. The neck joins the head at an angle. The hair goes above the oval. It's fitted on.

In drawing the front view you'll want to divide the oval into right and left halves to help you line up the eyes, now almond-shaped. The eyes are separated by an eye's width. In length the ears extend from the eyes to the tip of the nose. You may have trouble making the nose—it's wedge-shaped—project outward; your familiarity with foreshortening will help here. You'll make it a little bit wider at the tip, perhaps placing a slight shadow underneath.

The three-fourths view of the head is the most interesting. Here you have partly the problem of drawing a side view and partly the problem of drawing a front view. Again, to help you get your bearings, you'll run a line longways around the oval that'll mark the vertical center of the face, but it'll be over to whichever side the head is turned. Make the eyes curve around the oval; the one on the far side will be slightly smaller than the other. The space between the eyes is diminished. The far side of the mouth will be slightly smaller than the near side.

If your friends lose interest in posing, you can turn to a mirror. Use two of them for your side view.

CARTOON HEADS

We drop now the realistic approach and turn to cartoon or comic heads. Here's where the real fun of cartooning lies. We forget all the rules. The eyes go up higher on the head. The nose takes on a bulbous shape. In front views, it might not even bother jutting forward; it can just as well shoot out to the left or right. For pretty girls, head on, it can be dropped completely;

or maybe it can be retained as two small dots, representing nostrils.

We can even move away from the restrictions of the oval. To the cartoonists, heads can also be noticeably round, triangular (right side up or upside down) or square.

EXPRESSIONS

One of the most interesting expressions in cartoondom is the one showing evil intent. It's almost impossible for a real person to work his own face into such an expression, but it's easy for the cartoon character. He simply wears a broad smile (at the mouth) and a frown (emphasized by heavy eyebrows). You've seen the expression on the men chasing girls in gag cartoons. Occasionally Dagwood has it as he contemplates biting into one of his famous sandwiches or getting even with Mr. Dithers.

Eyebrows are the key to cartoon expression. Slanted down, they are part of a frown; slanted up, they show worry; high up above the eyes, they show surprise or fright; lined up straight, they show determination. Leave eyebrows out and you have your redhead or towhead.

The mouth plays a major role, too, of course. Crescent-shaped, ends up—laughter; crescent-shaped, ends down—sorrow; zigzagged—shock; X-shaped—sour taste; one end down—toughness.

Hands add the finishing touches to expressions. The angry man exhibits clenched fists; the skeptic holds one hand up, palm out, traffic cop fashion; the horrified girl clutches her hair, which, to show extreme terror, stands on end; the laughing man clutches his sides; the worried gentleman rubs his chin or holds his head in his hands. And so on.

TYPES

As you draw you should make a decision for each character as to what he is: kid, young person, middle-aged, elderly; worker or professional man; thin or fat; scholar or ruffian; leader or follower.

Kids (for their size) have larger heads than the rest of us. Their eyes have to be lower down on their heads. Their limbs

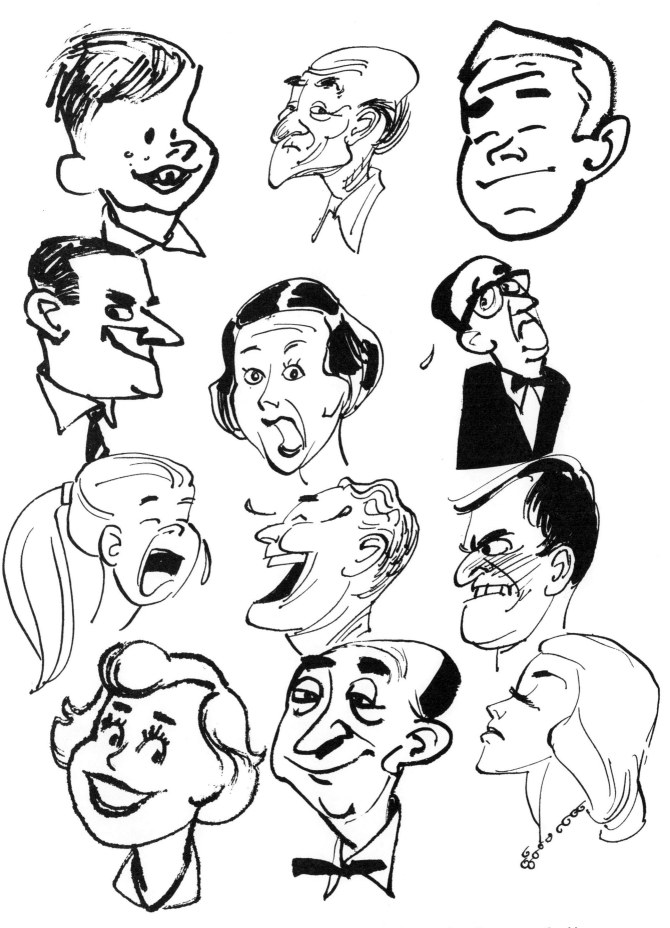

Some cartoon types and expressions. Top row: youth, old age, young-middle age. Then: an evil look, fright, worry, despair, laughter, anger, happiness, stupidity, snobbishness. Note flexibility of tear or sweat drop, used in three of the expressions here.

are less shapely. Old people have wrinkles, of course; thinning hair; sags. You can show them without teeth by running a series of short lines into the mouth.

The clothes on the working man should be unpressed, even soiled. The professional man is well dressed, probably paunchy.

The clothes on the thin man are full of long wrinkles; those on the fat man fit tight, with short wrinkles at the joints.*

Ah, and the pretty girl. Do pretty girls all look alike to you? Well, changing from solid black hair to pure white hair, à la Zack Mosley, is not enough. You should try different hair-dos (watch the magazine ads to keep up with them). You should try different forehead contours. You should, from girl to girl, change the shape of the nose, mouth, chin and neck. With these variations, you can still come up with a pretty girl whenever you want one. That's more than the guy next door can do.

But I have this suggestion: bring to cartoon life from time to time an average-looking or even homely girl. There are some of these around, too.

The cartoonist is often criticized for perpetuating and even creating personality stereotypes. To the cartoonist every weakling has a receding chin; every smart man or woman wears glasses; every thug has a low forehead and an unshaven pro-truding chin. Of course, you and I know personally people with receding chins who are frightfully strong-willed or dis-gustingly sturdy of build; we know people who wear glasses who couldn't tell Groucho Marx who's buried in Grant's Tomb; we've seen pictures of thugs who look like former teachers we've had.

While I try to stay away from personality stereotypes whenever possible, there are times when I find I must bring them into use. They may not be authentic, but they are recog-nized, and they are handy. Even the great liberal editorial car-toonist Herblock of the Washington *Post and Times-Herald* admits in his books that his work very definitely involves the manipulation of stereotypes.

* I hope I'm never quoted out of context on these paragraphs. I'm discussing people who live only in the world of cartoons, of course.

6

Animals

A breezy, illiterate country boy from Silverton, Oregon, became, at the turn of the century, probably the world's best-known editorial cartoonist. He was Homer Davenport, associated with the Hearst newspapers in San Francisco and New York and other papers in San Francisco, New York and Chicago.

His most widely reprinted cartoon was the one he did in 1904 for the *Evening Mail* showing Uncle Sam standing in back of Theodore Roosevelt, with Sam's hand placed affectionately on the shoulder of the Rough Rider. It was a simple drawing. The caption is what put it over: "He's good enough for me." The Republicans were so fond of that cartoon they used it as a campaign poster and for campaign buttons. Perhaps it was instrumental in helping Roosevelt beat a weak Democratic candidate.

Cartooning was an obsession with Davenport. His whole life—it was cut short by pneumonia in 1912—revolved around an ink bottle. But he had one other love: animals.

His being raised on a farm accounts for his early preoccupation with fighting cocks, horses, birds. (You'll enjoy reading his homy, illustrated book, *The Country Boy*). When a parade of Arabian horses moved through Chicago during the World's Fair, Davenport, a grown man, followed on foot for twenty miles. "It is hard to impress you how seriously I felt about this Arabian horse question," he later recalled. "I was afraid I would lose my mind over it. If you get your mind set on anything hard enough, you know, you can go insane over it. For days I

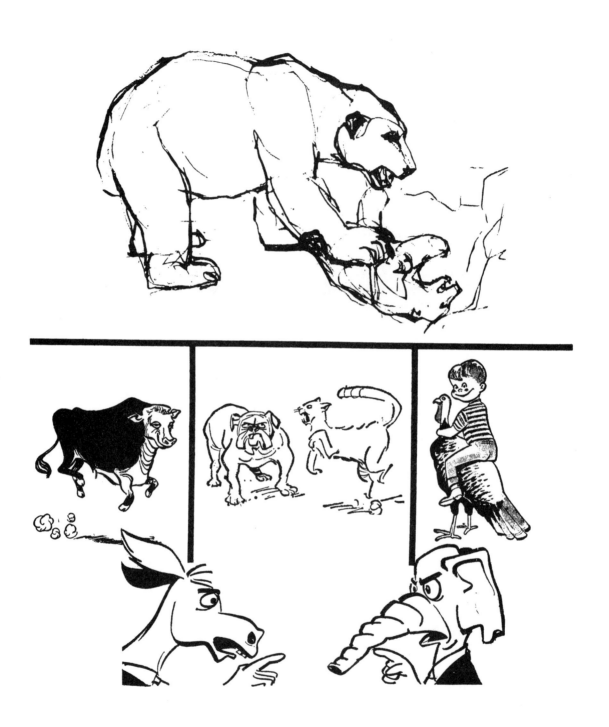

couldn't do anything just because of these horses." Later, earning a better salary, Davenport began collecting them, paying as much as $8,500 for one that later brought an offer of $20,000. And in Morris Plains, New Jersey, he set up a pheasant farm that by 1905 had some thirty-eight varieties, probably the largest collection then in the world.

His love of animals showed up often in his cartoons. His portrayal of the G.O.P. elephant, the Tammany tiger—these were superb! His horses, done in the fine crosshatching of the period, would practically jump right off his pages. They bore remarkable expressions. They were fun.

Some cartoonists have specialized in animals. Ed Nofziger, for instance. But his specialization has cost him some editors' acceptances, with America's taste veering away from talking animals in gag cartoons. T. S. Sullivant of an earlier age is best known for his comic animals. Other cartoonists are particularly effective with animals—like advertising cartoonist Roy McKie, comic strip artist Charles Schulz, and sports cartoonists Willard Mullin and Howard Brodie—but they are effective in their handling of humans, too.

Not all cartoonists share Davenport's and Sullivant's and Nofziger's enthusiasm for animals. As city folk, they may not be familiar with animals. Drawing the critters is a chore. Yet in their cartoons they must feature animals occasionally, especially if the cartoonists are doing political or sports cartoons, or illustrating children's stories.

Animals are no harder to draw than humans. It's just that a little research is involved. A trip to the zoo, museum or farm may be called for. If that's out of the question, there's always a picture morgue.

You should study a number of different animals at a single sitting, making sketches for your files, noting the basic differences in over-all shapes, in the bulk of the animals, in the leg lengths, the skin or hair texture, the features. For each animal, note the relationship between the head and body size.

Drawing animals effectively is a matter of observation. And practice.

Here are some basic rules that may not impress a veterinar-

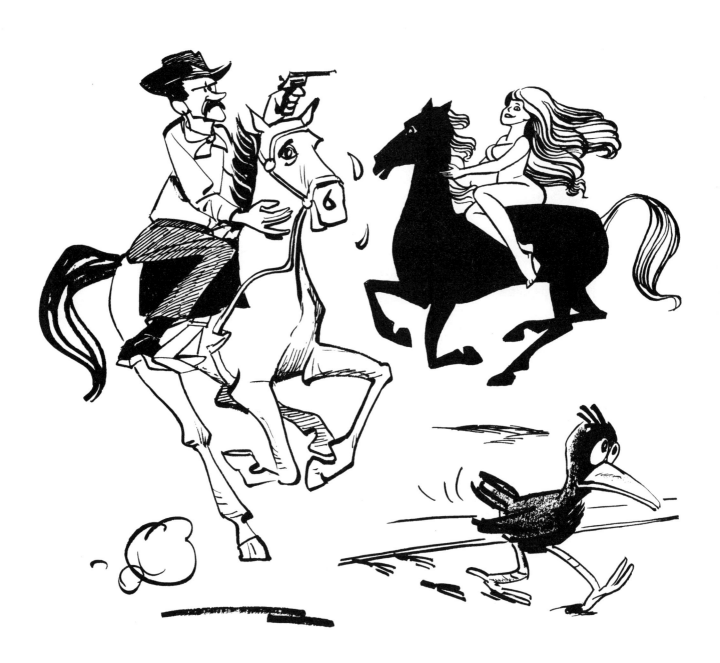

No Hiding Place

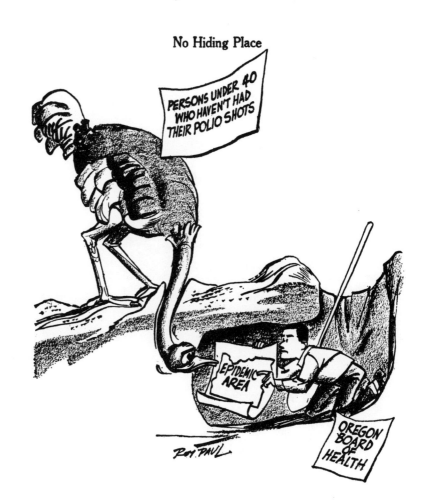

ian or zoologist but may help you create animals that'll fit into your cartoon world:

1. Think of the weight of the body of the animal as hanging down from the backbone, rather than as propped up on four legs. Picture the body as bulging slightly on the underside.

2. Think of the body as tapering slightly at both ends, allowing room for the legs to move freely. This holds for a top view as well as a side view.

3. Consider the legs as separate units, each moving independently of the others. They are not synchronized.

4. Remember that animals—even the large ones—are generally graceful, that their lines are rhythmic.

5. Consider animals not in outline but in solid form.

6. Rough in your animals first, then go to your morgue for details. Your morgue pictures are likely to be too actionless to copy directly.

7. For meat-eaters, keep the head and jaw powerful; for grass-eaters keep the head longer, the neck longer.

8. "Humanize" your animals. Exaggerate. Keep them funny. Too often a cartoonist, unfamiliar with animals, "tightens up" when he draws them. His animals take on a stiff realism.

7

Backgrounds

Although it's true that the best cartoons today are the simple, uncluttered ones, it is also true that most cartoons have at least a suggestion of background. And in most cartoon situations, there must be some up-close props for the main figures. These will be our concern in this chapter.

For drawing background and props, many cartoonists rely on a ruling pen, a French curve and other mechanical devices. Your use of such devices will depend on whether you have a tight, fussy style or a loose, free style.

More important than mechanical devices for backgrounds is the artist's "morgue." A morgue is a library of pictures, usually clipped from magazines and, to a lesser extent, from newspapers. It takes years to build a really useful morgue. What often plagues the artist during the morgue's early years are assignments to draw a kangaroo, say, or the Parthenon—items which may not be in the picture library. A good illustrated dictionary and an encyclopedia might help here and, as a matter of fact, will serve as a useful supplement to even a well-developed morgue.

THE NEED FOR A MORGUE

Why a morgue?

It's for research. No artist can hope to carry in his head

precise pictures of how people in the 1890's dressed, what kind of foliage and trees are typical of the South, what tools a gold miner uses, how a football stadium is laid out. He refers to pictures of these things. He notices the detail. If he's a cartoonist, he uses only detail that is vital. But what he *does* use will have to be accurately portrayed, or, if the cartoon is published, there'll be a number of "don't-you-know-any-better?" letters to answer.

An important point to make is this: the research in the morgue should be for authenticity of detail or pose, not for technique of drawing. Although you will want to set up a file of the work of cartoonists and artists you admire, and you'll want to study this work from time to time, you should not rely on such material for background and props (or figures) for your own drawings.

The ideal situation is to draw directly from the item being pictured. The next most ideal situation, I suppose, is to work from reconstructed scenes or stuffed animals. Then comes working from photographs or reproductions of photographs. When you go a step further, and work from drawings, you are too far removed from the original. No self-respecting artist relies on someone else's research.

Because it's the practical way to do research, you'll work mostly from printed photographs—from your morgue.

The best sources for material with which to build a morgue are magazines like *Life, Look* and *Holiday. National Geographic* is perfect for some areas of your morgue, but most people are reluctant to part with back copies. If you tend to specialize in your cartooning, you'll probably want to collect illustrated books on your specialities.

In my morgue the animal files get the most use, not because I specialize but because, as a city boy, I don't know one hoof from another. The animals in the last chapter would have given me plenty of trouble without some scrap to go by. Even a fairly complete morgue is far from adequate. The artist should learn to develop his own creative abilities so that he can improvise where necessary. One of the dangers of working from a morgue is that the artist tends to arrange his composition around what he has in the file. Such an artist cheats his audience —and himself.

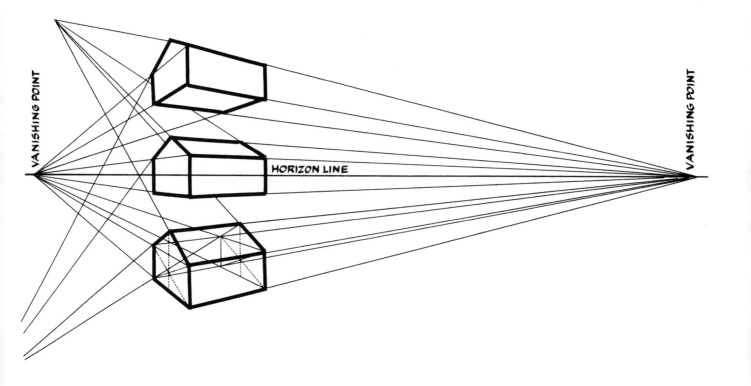

VANISHING POINT

VANISHING POINT

HORIZON LINE

Here's how a simple structure would look above, on, and below the horizon line. The sloping roof lines require separate vanishing points not on the horizon line. To establish the apex of the roof triangle, bisect the two sides of the basic cube, then send up perpendicular lines (illustrated on bottom house).

BACKGROUNDS

Every artist has his own filing system, but as a suggestion I offer you the following list of forty-four morgue topics (each of which could have a folder for alphabetical filing):

1. Aircraft
2. Amusement
3. Animals
4. Architecture
5. Autos
6. Birds
7. Boats and ships
8. Celebrities
9. Characters
10. Children
11. Costumes
12. Countries
13. Crowds
14. Disaster
15. Education
16. Family
17. Farm
18. Fish
19. Food
20. Furnishings
21. Government
22. Holidays
23. Industry
24. Landscape and gardens
25. Medical
26. Men
27. Music
28. Police
29. Prehistoric
30. Railroad
31. Religion
32. Restaurants
33. Romance
34. Scenes
35. Science
36. Society life
37. Sports
38. Stores
39. Transportation (mass)
40. Trees
41. War
42. Weddings
43. Western and Indian
44. Women

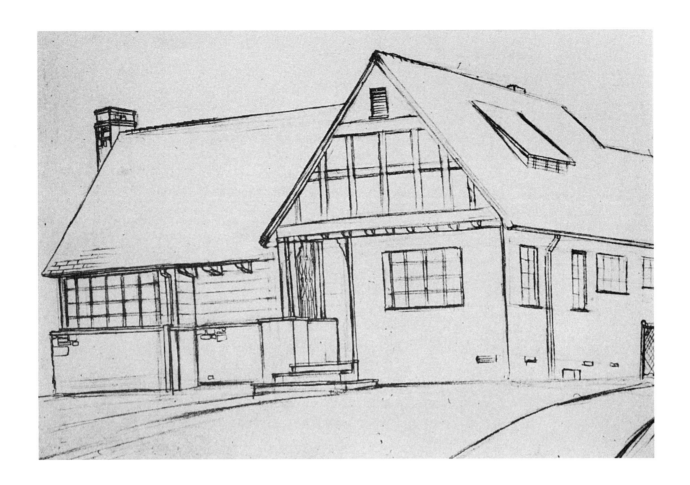

Note how drawing was improved when the vanishing points were moved closer together and when laws of perspective were consciously applied.

BACKGROUNDS

You may want a more comprehensive file. And I think you'll want to break down your "animals" section into several folders. You may want to add special folders, too, for technique, use of color, lettering, etc.

PERSPECTIVE

This is probably the most frightening subject of all to the beginning cartoonist. If you go into the subject fully, it *is* rather complicated. Here we need not go into it fully. A few basic principles will suffice to give you the necessary confidence to solve your prospective perspective problems.

What the cartoonist is trying to do in his background drawing is to get a three-dimensional effect on a two-dimensional surface. Thus, the side of a building nearest the audience is made larger than the opposite side, and a figure near the audience is made larger than a figure farther back in the drawing. Items up front in the drawing are made darker and given more detail.

The first step, in working out the perspective of a drawing, is to establish the horizon line, or the eye level of the picture. If you choose to make it high in the picture, you'll create the effect of an aerial view. If you make it low, you'll have a worm's-eye view. Most cartoonists put the horizon line somewhere near the middle of the picture, but it is a good idea, for the sake of variety and interest, to push it higher or lower.

If you're a beginner you may find it helpful to put all props and figures in boxes and work out the perspective for the boxes. Parallel lines converge, of course, to a common point on the horizon line. An ordinary box, unless it is viewed head on, would have two "vanishing points" along the horizon line. Where you have diagonal parallel lines (as on a roof of a house) you must establish an additional vanishing point, one not on the horizon line. In aerial or worm's-eye views, vertical lines, too, should be made to converge at common vanishing points.

It is a rare cartoonist who goes through the process of conscientiously extending converging lines and establishing, mechanically, several vanishing points for his drawing. Most cartoonists play it "by ear." To be effective, the perspective, in a

cartoon, should be a little exaggerated. The vanishing points, in other words, should be fairly close together on the horizon line. Note how I have improved the drawing of the house by pulling the left and right vanishing points in closer to the center.

Not only does a cartoonist exaggerate the perspective; he also, for some occasions, distorts it completely. In drawing the man at his desk I purposely made the edges at the extreme right and left of the desk bigger than the center edge, even though the center edge is nearer to the onlooker. My reason: just that I thought it would be more interesting to look at.

8

Composition

Composition is the arrangement of elements within a cartoon to produce an over-all pattern or design that is both pleasing and appropriate to the subject.

Knowledge of what makes a composition good will do much to make your work look professional. A poorly composed picture will fail to impress even a layman. He'll not know *why* he doesn't like such a picture. He'll just know he doesn't like it. Somehow, it doesn't have the right "feel."

There is no 1-2-3 formula for good composition, but there are a number of principles that deserve consideration here. Take the matter of balance.

BALANCE

To say that every cartoon you draw should be "in balance" is not to say that every item in the picture has to be placed half-way between the left and right margins. In some cases, perhaps, a formal balance is fitting, but in most cases you should strive for *informal* balance. In most cases you'll want to get important action off to one side and then lead the eye to that spot. And you'll want to let the horizon line fall below or above the actual center of the page.

But what happens when you put a heavy figure or item to one side? The picture is off balance unless you move something

over to the other side as a counterbalance. Think of your drawing area as a sort of seesaw or teeter-totter. You'll recall that when you made use of these playground devices you sat well out to the edge if you were light, and your partner, if he was heavier, sat nearer the center. In this way, you were able to achieve a balance, even though your weights were quite different. The same principle holds true in arranging elements in composition.

Visually, bigger things are "heavier" than smaller things, of course. Also, darker things are "heavier" than lighter things; irregular shapes are "heavier" than smooth shapes.

It is impossible actually to weigh the elements you put into your drawings, but when you have them roughed in, step back and try to "feel" the weights. Turn your drawing upside down. Hold it up to a mirror. To make this sort of experimentation really effective, do a tissue paper overlay, filling in the blacks with charcoal or soft pencil, much as you plan on the final inked drawing, and then determine whether the work is "in balance."

PROPORTION

A point suggested by the preceding paragraphs is that things which are centered are not as interesting as things which are not centered. Similarly, things which are much the same in size are not as interesting as things which are quite different in size.

Not only should you be on guard against putting several items of the same size in your drawing; you should also refrain from drawing items that are exactly twice as large as other items in the cartoon, or three times as large, or half as large. Make your relationships more subtle. Make one item *just a little* larger than another—or in some cases a good deal larger.

The best source of inspiration in this matter of proportion is your own hand. Notice the subtle differences in the lengths of your fingers; in the lengths of distances between joints.

Another reminder is the paper you are reading from. Note that the vertical edge of the page is longer than the horizontal edge. Opened out, the book becomes wider than it is deep. If

you want to reduce this to simpler terms, a pleasing proportion to strive for is 3 to 5.

The principles of good proportion hold for the relationships among elements within the drawing, as well as for the relationship between the width and depth of your over-all drawing area. A square shape is not as interesting as a rectangle.

MOVEMENT

The eye naturally travels from left to right and from top to bottom. If you could arrange the elements in your drawing with this in mind—across the page, then down the page, say, from the upper right corner to the lower left corner, then across the page again, left to right—you'd know the viewer would be "reading" them in the order you intended. But this sort of arrangement is seldom feasible.

It is also true that the eye lands first on the largest or darkest or "heaviest" item in a picture, and moves to successively smaller or lighter elements. Arranging your elements to take advantage of this natural eye movement is not hard to do.

You should be conscious, in each of your drawings, of some basic shape formed by the eye travel of the onlooker. The letters of the alphabet can be used as forms on which to build your composition. You may find it helpful to study a number of cartoons (and fine drawings and paintings) and try to reduce the eye travel to basic shapes.

The elements in your drawing should be tied together, either by setting up an effective eye path through the picture or by overlapping the elements (which is another way to direct eye travel). A common fault in composition is to place a number of unrelated elements in a picture, without a focal point, letting each one fight for attention.

EMPHASIS

Now for perhaps the most important point of all in composition, suggested by the last paragraph. One element should dominate your drawing. There should be one emphasis.

You can emphasize, of course, by size. You can also emphasize by unusual shape, tone or color.

Instead of calling this principle the principle of emphasis, we could call it the principle of contrast. To make your composition pleasing, you should strive to break the monotony with an element quite different—in size, color, shape—from others in the drawing. The element of contrast usually will be the one you'll be emphasizing.

HARMONY

One last principle you should concern yourself with is the principle of harmony. The elements in your drawing should "go together." They should all look as if they were done by the same artist. No single cartoon should attempt to contain both realism and abstraction; nor should it be both loosely drawn and tightly drawn. It should be one thing or the other.

Attempting to satisfy all these requirements could drive you to tranquilizers, but you should take each into consideration. With some experience, you'll find you'll quite unconsciously achieve pleasing balance, proportion, movement, emphasis and harmony in each of your cartoons.

CONTACT POINTS

These are points to avoid. They occur when the edge of a man's arm, let's say, is drawn exactly where the edge of a door is drawn, or the top of his head ends exactly where the bottom of a picture occurs. There is set up, then, a peculiar arrangement between the elements: it looks as if the man is supporting the door or balancing the picture on his head. The reader is bothered and confused.

Keep elements completely separate, or really overlap them.

LIGHT AND SHADE

A final topic to consider under "composition" is light and shade. In many of your cartoons, you'll not be bothered by the problem. To produce some gag cartoons you'll work strictly in line. But even in a line drawing you may want to vary the thickness of the line. Where you make the line heavy, you suggest a shadow.

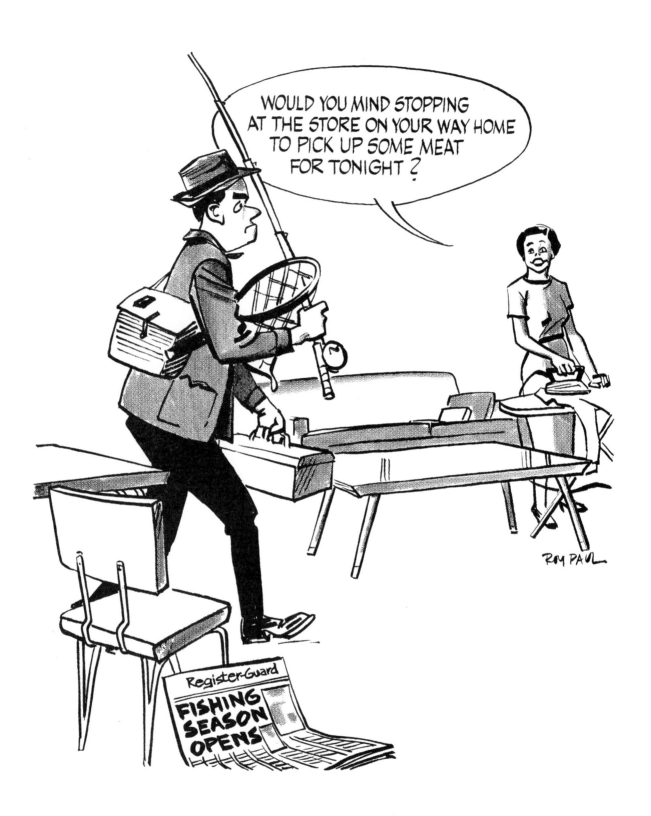

Unity is achieved in this cartoon by overlapping elements, cutting down on background, pushing white space to outside edges. Note the "silhouette" of completed drawing.

In editorial cartoons and in many comic strip features you *will* be concerned with light and shade. A first step is to establish in your mind a light source (sunlight or artificial light) and figure out where the shadows would fall. Very dramatic effects can be obtained by placing the light in an unusual position, say in front of the subject but low in the composition.

Your problem will become a good deal more complicated when you establish two or more light sources. Let one predominate.

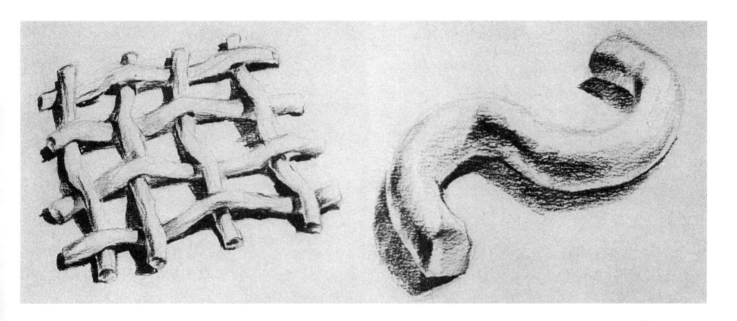

One way to study light and shade is to get some clay, mold it into various shapes, shine a rather harsh light on it, and witness what takes place. You can also use real objects or live subjects, of course.

In working with light and shade, notice that there are, basically, two types of shadows. There are those with a harsh edge (produced when an element gets in the way of the flow of light) and those with a soft edge (produced, as along the side of a tube, when light "leaks" around a corner).

It is possible—and good practice—to draw entirely in shadows, without benefit of outline.

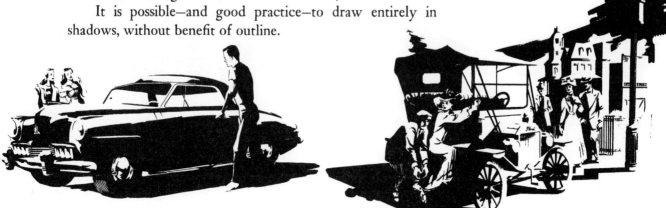

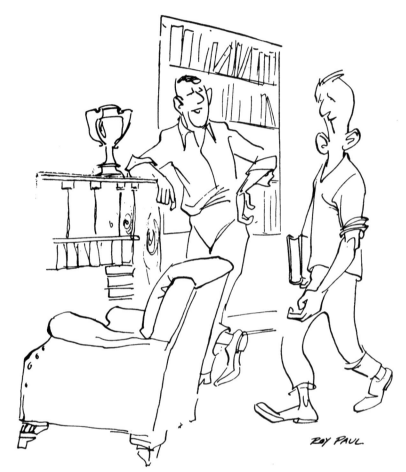

CAMPUS Magazine

"I see you got your ears lowered today."

9

Gag Cartoons

There are those who suggest the magazine hasn't been the same since the death of its founder and long-time editor, Harold Ross, but still no periodical is more of a credit to American journalism than *The New Yorker*, a happy combination of great reporting and a casual writing style—a rather uninhibited magazine that mixes good humor with social consciousness. Of its contributions to the American scene, none is more appreciated than the one-line gag cartoon. If *The New Yorker* didn't invent this type of humor, it certainly pioneered its development in this country.

Even today *The New Yorker* is the Rolls-Royce among magazines carrying gag cartoons. No other magazine comes close to matching the humor turned out by its stable of regular contributors.

Reading gag cartoons is a favorite pastime of millions, both low-brows and intellectuals. Producing them is fun, too.

Few cartoonists, even well-known professionals, can break into the select group of gagsters at *The New Yorker*, to crack that sophisticated market, but there are many, many other magazines whose cartoons are good, whose editors can be sold to. You don't have to have a reputation. You don't even need much drawing talent. But you do have to have some fresh ideas.

To the beginning cartoonist it often comes as a disappoint-

ment that good drawing is of minor importance in the marketing of gag cartoons (although many of *The New Yorker* cartoons stand as examples of fine art). It's the idea that counts. Incidentally, an undetermined number of persons make their living, or at least part of it, "thinking up" ideas and selling them to cartoonists for a percentage—usually 25 percent—of the take.

Acceptable cartoons bring from $5 to $100 and up, depending upon the magazine to which they are submitted.

The majority of markets are situated in New York, and many of the cartoonists live there, making the rounds each Wednesday (a day agreed upon by editors as "market" day) with their roughs, hoping editors will be impressed. Some editors buy the roughs "as is," others ask the artist to redo them, in a tighter form, perhaps even specifying which medium should be used.

Many cartoonists rely on the mails to submit their work, and there is a considerable number who sell in this way, even to high-paying slick magazines.

There is much competition. Marione Nickles, former cartoon editor at the *Saturday Evening Post*, looked at up to twelve thousand cartoons a month, from which eighty were chosen for publication.

Gag cartoonists who sell regularly have a number of batches out to editors all the time. Each gag is numbered. Records are kept. John Norment tells of a cartoonist friend who drives to the post office every Saturday for his mail. He puts it on the seat beside him and drives back home. "On the way," says Norment, "he opens the envelope from the *Post* with one hand, slides his hand carefully inside and runs his fingertips along the slip enclosed. The rejection slip from *S.E.P.* is *printed*. The slip that comes with the OKs is *embossed*. My friend can keep both eyes on the road and feel if he has made a sale or not."

"It is a good idea to follow a routine whereby each market that you regularly submit to has a frequent look at your material," says Joe Pierre, gag cartoonist and an editor for *The Pro*. "The editor will become familiar with your work and will recognize you as 'regular.' "

There are several specialized publications which serve gag

"I always stop where the tourists stop. They know all the best eating places!"

"You understand—that's only an estimate."

cartoonists and gag writers, publications which analyze current trends and list markets and rates of pay. Among them are:

The Pro, *819 N. Lombard St., Portland 17, Oregon.*

New York Cartoon News, *3161 N. E. 17th Ave., Ft. Lauderdale, Florida.*

The Gag Recap, *P.O. Box 425, Paramount, California.* (*Summary of gags published, by gags, artists, magazines*).

Information Guide, *P.O. Box 3097, Lincoln 10, Nebraska.*

The Trade Journal Review, *Box 308P, Morgan Hill, California. (Like* Gag Recap, *but for trade journal cartoons only*).

Subscription to any of these is rather steep, but many cartoonists find the investment pays off. *Writer's Digest*, which you can pick up at any large newsstand or at your library, runs a column each month devoted primarily to the gag cartoon field. The annual *Writer's Market*, a book published by *Writer's Digest* magazine, carries several pages of cartoon markets. The annual *Writer's Yearbook*, available on newsstands, also has information on where to sell cartoons.

Contributing only to those magazines you see or are familiar with is best. Gag cartoons should be "slanted" to the magazine; some editors prefer one type, some another.

The most likely magazines to buy the work of beginners are the trade magazines, but their pay is considerably lower than that of the general circulation magazines. I began selling to the trades while I was a high school sophomore.

Here's how to prepare a batch of gag cartoons for mailing: Draw up in ink a dozen roughs or so, on 8½ by 11 paper. Ship the package flat, preferably with a piece of corrugated cardboard to prevent bending. Include a stamped, self-addressed envelope *large enough* to hold your drawings. The post office has ruled gag cartoons can go third class; but you'll be more satisfied with first class handling. No note to the editor is necessary.

THE DRAWING STYLE

I did not mean to suggest in the early part of this chapter that sloppy drawing is the rule for gag cartoons. I simply wanted to call your attention to the fact that a poor draftsman with good ideas has a much better chance to succeed than a good draftsman with inferior ideas. Personally, I would classify the drawing of Tom Henderson as not much higher than that of Zack Mosley ("Smilin' Jack") or Edgar Martin ("Boots and Her Buddies"), but, because his ideas are hilarious, Henderson is a giant among the gag cartoonists. You may recall his remarkable cartoon showing a man in a tuxedo standing in front of a seated society lady at a very high-class party, with his foot in her lap, saying: "Well, I must say I've enjoyed this little informal chat with you this evening, Lady Winsted."

A study óf the work of such gag cartoonists as George Price, Lichty, Tobey, Saxon and Claud should convince you that there are, among the gag cartoonists, some men (and women) who are excellent artists.

Some editors like a "tight" style, with detail rather carefully drawn; others appreciate a "loose" style, with detail only suggested and with outlines rather fuzzy or undetermined. A "loose" drawing looks as though it were drawn in a hurry, and often this is true; it is also true that a loose-style artist will often not be satisfied with some of the elements in his hastily drawn cartoon, so on a separate sheet of paper he'll redraw these elements, pasting them in place over the original versions. Lichty is a great patcher. Such patching does not show in a line reproduction. Almost every cartoonist does a certain amount of "touching up" with white show card color or Chinese white.

TYPES OF GAGS

You have probably read that there are only a few basic plots used by novelists and short story writers. All stories are but variations of the basic plots.

Similarly, there are only a few basic gag cartoon ideas.

Let me call your attention to some of them.

1. THE CLICHE. This involves taking a well-known or trite expression, and carrying it out to its literal conclusion.

"Vip" is the most successful of the cliché-users. Consider his classic, "Boy! If looks could kill, eh, Steve?"—a cartoon showing poor Steve lying dead on the sidewalk while his friend, unaware of the catastrophe, turns to watch a cranky woman who's just walked by. In this category, we might also include the simple pun or play on words. Take "Vip's" drawing of a sinister ball player who's just gotten to third base, and who is tying a handkerchief around his face. Says a player in the field, to the third baseman: "Watch him! He's going to steal home."

2. THAT'S LIFE. This classification includes those cartoons that cause reactions among readers like these: "Why, that's *me!*" or "Isn't that just like a man?" "Exaggerated realism" might be another heading for this kind of gag. There's Stan Hunt's husband, home from work, grumpy, reading the paper, apparently disturbed by the kids in the next room watching TV. The wife is standing over him, saying: "Jim, you must stop referring to the children as personnel." There's Tom Henderson's unshaven, lazy husband, sitting, reading the paper. The wife has been out shopping, and by the looks of things she's spilled all her groceries trying to get to the phone before it stops ringing. It happens to be right next to her unconcerned husband. She says, "Yes, he's here." Then there's Chon Day's drawing of the pooped middle-aged man, sleeping on the davenport. The wife, matronly-looking, explains to a visitor: ' He's had a bad back since he carried me over the threshold."

3. HOPELESS OR RIDICULOUS SITUATION. There's something funny about real predicaments, if they happen to the other guy. I cite my favorite gag cartoon, by Robert Day. There's a completely empty stadium and a rather worried radio announcer with his spotter. He's saying, "Well, folks, here it is starting time! . . . One moment while we take a look at that little old schedule."

4. OUT-OF-CHARACTER. This is a popular type of gag cartoon that gets its laughs by showing a character doing something he ordinarily would not be expected to do. Old ladies playing pin-ball machines. Housebreakers taking time out to feed the cat. And so on.

5. IN-CHARACTER. Somehow, just seeing people act as you would expect them to act becomes funny. This is the "bus-

man's holiday" in cartoon form. You may recall the cartoon showing a cowboy turning to see a weird-looking Marsman walking toward him. The Marsman evidently has just alighted from a flying saucer. The cowboy says: "Howdy, stranger!" Frank Modell shows a mean-looking wife, who's just shot her husband, talking into the phone: "And one more thing, Lieutenant. Tell your men to wipe their shoes before they come tramping in here."

6. STUPIDITY. The main character in a cartoon misses the point and we laugh. If she's blond, somehow it's funnier. There is a certain thrill here for the reader, because he has the satisfaction of seeing what the cartoon character missed. Here's one: Reamer Keller shows two old ladies on the porch of a house situated high on a hill. The postman is just leaving, climbing down a winding, precarious stairway. Says one lady: "I've never seen him smile."

7. INVENTIVENESS. Come up with a clever way of solving a usual problem, and, if it's unpatentable, it may at least be cartoonable. This type of cartoon often does not need a caption. Wiseman, in a *New Yorker* cartoon, shows a poker game among Indians, with a bystander signaling one of the players with smoke from his pipe; Modell, in another *New Yorker* cartoon, shows a hospital cigar-dispensing machine next to the maternity ward. If the cartoon character succeeds in flouting authority, this holds a certain thrill for the reader, too. Maybe he's looking at his wife through the small end of a pair of binoculars (Steig).

8. UNDERSTATEMENT. Now we are dealing with humor on a fairly high level. This is a type of humor, often associated with the British, which depends upon a choice of words that is not really adequate. It is the opposite of exaggeration. A large percentage of gag cartoons can be classed under the heading, "Understatement." An example is Porges' cartoon showing some businessmen beating each other up. One of the group peeks through a door and announces to a reporter: "The merger is off."

Seldom will a good idea just hit you. You'll have to work for it. You might find it profitable to hunt through magazines and books, paying particular attention to the photographs and

illustrations. Spend some time with each picture, toying with captions. Perhaps methodically applying to assorted pictures captions of the type described in this chapter will prove fruitful.

Transformation

10

Comic Strips and Panels

Critics of the press are disturbed over the tendency of American newspapers to standardize their content through the use of syndicated materials. Cartoonists have a right to be disturbed about syndication too. When a newspaper subscribes to the services of a syndicate it is not likely to be interested in the work of a local boy.

There are two reasons why newspapers go for syndicated material:

1. Syndicated art is cheap. Because many newspapers subscribe to the same feature, each need pay only a small part of the artist's and the syndicate's total price.

2. Syndicated art, looking at it from the newspaper's standpoint, does not have to be engraved. It comes to the newspaper in "mat" form, ready for casting.

Why should a newspaper pay even a moderate salary or fee to a local comic strip artist and then pay an additional five to fifteen dollars for a single engraving, when for a few dollars a week the paper can get a whole seven days' worth of artwork from a nationally known cartoonist?

But there is a big disadvantage to the editor in the use of syndicated material. The material is not localized.

There is always a chance that the paper will be interested in buying from a local artist a feature that deals with the

region's own people, its history, scenery, industry, advantages, peculiarities. For the moment, though, let's assume you are interested in doing a feature for one of the syndicates.

THE COMIC STRIP

When I suggested that cartoonists are hurt by syndication I of course was excluding those cartoonists who have managed to sign a contract. There are more than 150 syndicates, but not many of them are of the size of King Features or United Features or Newspaper Enterprise Association. Many of them are one-man operations or offer only one or two features. They all usually work on a half-and-half basis; half of the fees collected go to the artist, half to the syndicate. For the man who *does* connect, a healthy salary—going even beyond $100,000 a year—is possible.

It should not be implied that the syndicates are not looking for new material. They certainly are. But any new feature has to be unusual, and it has to appeal to large numbers of readers.

Although it is true that whenever there is a successful strip launched, several others, sponsored by rival syndicates, crop up to compete, a beginner's best chance for syndication lies in the creation of something new in comic strip entertainment. Perhaps after looking at a new strip, or a well-established one, you have said to yourself, "Why, I can draw as well as that," or "I could do a strip as good as that one." But matching the quality of an existing strip is not enough. A syndicate editor is not likely to drop a proved feature to take on one that's just as good. If you're serious about comic strip production, you should develop a product that is superior.

For the beginner, some comic magazines offer a more responsive market for comic strips—especially adventure strips—than do the syndicates.

THE IDEA

As in every other form of cartooning, the worth of a comic strip depends more on the idea than on the drawing. Some cartoonists who are good craftsmen have teamed with writers to produce a successful strip. But you gain a great deal

His Fair Lady

more satisfaction, I think, when you are able to handle the entire job.

Where do you get your ideas? There is no easy answer to this question, to be sure, but this advice is sound: Read. You can't expect to pull ideas out of a vacuum. You have to be stimulated. Even those ideas that "just seem to hit" you in the middle of the night are an aftermath of some reading or listening or observing hours or days before.

If you are working on a truly "comic" cartoon, you don't necessarily have to read comedy. You can study *any* subject—economics, politics, social conditions, or more lowly subjects like cooking, recreation, building, etc. Your whimsical comment on a chosen subject becomes the basis for a cartoon.

The successful comic strip usually features one character, and all the action is built around this character. Some comic artists tire of their central characters, and, although their strips still bear the titles of these characters, the action moves over to involve other characters for months at a time.

Be satisfied to make a single point in your strip or panel. Too often a cartoonist tries to get too much into his work—too much detail in drawing, too much comment in the lettering.

If you want to be published, I suggest that in your strip you avoid controversial subjects and that you remember your product should be geared for family readership.

One thing you'll have to decide is whether you're going to allow your character or characters to grow up. Not very many cartoonists have permitted their characters this luxury (King with his "Gasoline Alley" is an exception), but it is interesting, going back to early issues of a strip, to see how characters have changed, perhaps without the artist's realizing it.

A tough problem the untried comic strip artist faces is that of drawing the character to look like himself from every angle. Prior to working up any panels of your comic strip, practice drawing your main character from every angle, over and over again. Establish firmly in your mind just what he does look like —what kind of features he has and how these features appear foreshortened and from extreme angles as well as from the more common vantage points.

THE ADVENTURE STRIP

You have often heard lamentations over the demise of the genuinely funny comic strip and the rise of the adventure strip. There has been an occasional launching in recent years of a real "comic" strip—"Beetle Bailey," "Pogo" and "Peanuts," among the better ones—but the illustrated stories of lawyers, doctors, detectives, cowboys, explorers and just plain adventurers continue to occupy most of the space in the "comic" pages.

The artist who is interested in realism is most at home with an adventure strip. He probably excels in figure or life drawing. More than his comic artist friends, he is concerned with detail and accuracy in his drawing. He probably has a well-developed morgue and perhaps a camera—a Polaroid Land Camera, in many cases, to give him pictures in a hurry—so that he can easily find the poses and settings he needs.

More often than not he wrestles with problems of light and shade—problems that a comic artist is able to by-pass conveniently. He is also more attentive to folds and wrinkles.

A problem peculiar to the adventure strip, and even to the comic strip, involves the Sunday issue. Not every paper that subscribes to the daily strip buys the Sunday strip. In some cases, the paper doesn't publish on Sunday. The artist doesn't want to forge ahead on that one day without part of his audience, and he doesn't want to bore his seven-days-a-week readers with a rehash on Monday of what went on Sunday. Yet this latter procedure is perhaps the most common. Some artists ignore the problem and on Monday carry on as though everyone saw Sunday's strip. Still others—Al Capp ("Li'l Abner") and Roy Crane ("Buz Sawyer") are notable examples—run an entirely different series for Sunday.

Because of the importance of plotting, the man who looks for a career producing an adventure strip would do well to study the art of novel writing.

THE PANEL CARTOON

Closely allied to the comic strip is the panel cartoon. Examples are Ripley's "Believe It Or Not," Jimmy Hatlo's "They'll Do It Every Time," regular gag cartoons like Hank Ketchum's "Dennis the Menace" and those one-column car-

KING OF THE ROGUE
ROBERT DENISTON *HUME*
1845-1908

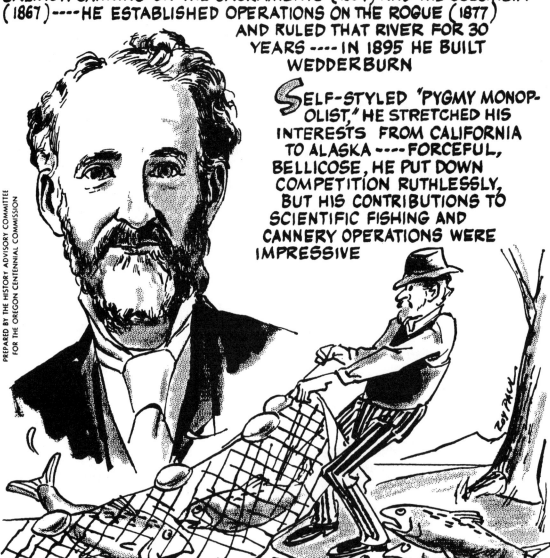

WITH HIS BROTHERS AND WILLIAM HAPGOOD HE PIONEERED SALMON CANNING ON THE SACRAMENTO (1864) AND THE COLUMBIA (1867)----HE ESTABLISHED OPERATIONS ON THE ROGUE (1877) AND RULED THAT RIVER FOR 30 YEARS ---- IN 1895 HE BUILT WEDDERBURN

SELF-STYLED "PYGMY MONOPOLIST," HE STRETCHED HIS INTERESTS FROM CALIFORNIA TO ALASKA ----FORCEFUL, BELLICOSE, HE PUT DOWN COMPETITION RUTHLESSLY, BUT HIS CONTRIBUTIONS TO SCIENTIFIC FISHING AND CANNERY OPERATIONS WERE IMPRESSIVE

PREPARED BY THE HISTORY ADVISORY COMMITTEE FOR THE OREGON CENTENNIAL COMMISSION

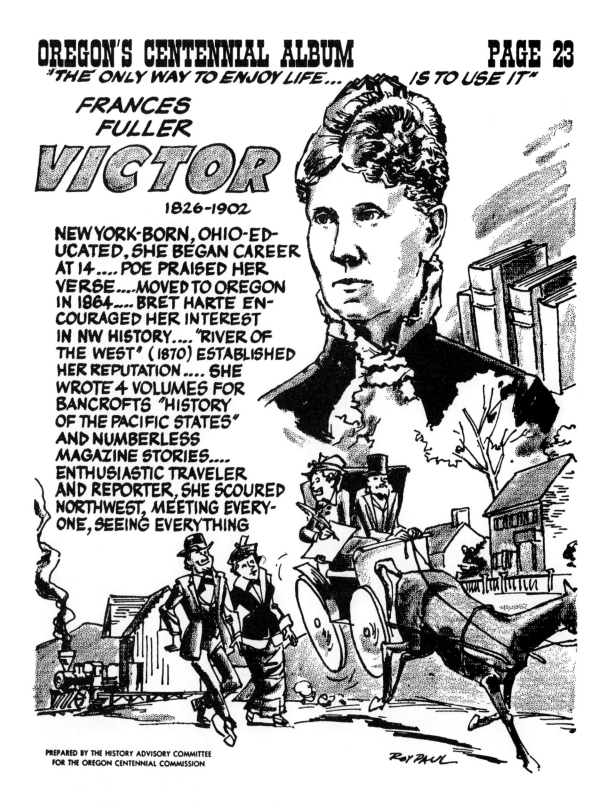

"THE ONLY WAY TO ENJOY LIFE... IS TO USE IT"

FRANCES FULLER VICTOR

1826-1902

NEW YORK-BORN, OHIO-EDUCATED, SHE BEGAN CAREER AT 14.... POE PRAISED HER VERSE....MOVED TO OREGON IN 1864.... BRET HARTE ENCOURAGED HER INTEREST IN NW HISTORY.... "RIVER OF THE WEST" (1870) ESTABLISHED HER REPUTATION.... SHE WROTE 4 VOLUMES FOR BANCROFTS "HISTORY OF THE PACIFIC STATES" AND NUMBERLESS MAGAZINE STORIES.... ENTHUSIASTIC TRAVELER AND REPORTER, SHE SCOURED NORTHWEST, MEETING EVERYONE, SEEING EVERYTHING

PREPARED BY THE HISTORY ADVISORY COMMITTEE FOR THE OREGON CENTENNIAL COMMISSION

Roy Paul

These two historical cartoon panels were part of a series syndicated weekly during Oregon's recent year-long Centennial celebration.

toon features which, because of space limitations, have become popular editorial and news pages throughout the country.

The comic strip artist draws his strip larger than it appears in print, giving him room to work in. For the correct proportion of width to depth, measure off an already printed strip and double (or triple) *both* the width and the depth. The engraver will be able to reduce your drawing to the desired size.

Your lines should be clean and strong, to take the reduction. For tones, a blue pencil Ben Day indication is fine; or you may use Zip-A-Tone or Craftint paper (see Chapter 2). If you're putting together a Sunday strip, don't put color directly onto your drawing. Show on a tissue overlay or on a photo-print copy of your strip what colors you want and where you want them to go. A syndicate staff artist and the engraver will take care of making the color separations.

From panel to panel you should strive for a variety of poses and angles. Occasionally you might want to show your characters only in silhouette. Occasionally you might want to leave off a panel's outline.

Among the humorous strips there is a trend toward small, even-size panels (always four to a strip), that can be run by the paper straight across, two over the other two, or up and down.

The conversation of your characters goes into balloons. Make sure the balloons are placed in the right order. Remember the reader goes from left to right and from top to bottom. Make sure the printing is large enough, and dark enough. There is no harm in being too easily read. (More about lettering in Chapter 13).

Syndicates, in considering the adoption of a new feature, like to see at least a two-weeks' sequence. And if you're interested in launching a comic strip or panel, get started young. Because of the cost of pushing a new feature, and building it up, the syndicates like to have you around for a while. When you *do* pass on, they'll push a staff artist or understudy in to carry on.

Editor & Publisher Year Book, available at libraries or newspaper offices, lists syndicates and their addresses.

11

Editorial Cartoons

With the decline in the United States in the number of daily newspapers published, a decline that started in 1910, and with the increased activity in syndication, the opportunities for employment as a newspaper editorial cartoonist are probably not so good as they once were. Nor is today's cartoonist so free to sound off.

Let's go back for a minute to the late 1800's, a period described by Roger Butterfield as "the golden age of political cartooning." Thomas Nast dared depict—and label—elected officials looting the public treasury; Joseph Keppler pictured the "Bosses of the Senate" as fat, wealthy business trusts; Art Young (we're moving into the 1900's now) drew the inside of a bawdyhouse and labeled the madam as a newspaper publisher and the patron as an advertiser.

Today's publications are not as willing to permit such attacks by their cartoonists. They have a healthier respect for libel laws. And, understandably, they are less inclined toward controversy; controversy makes readers mad and advertisers nervous.

The cartoonist of today is hardly the molder of public opinion the earlier cartoonists were. In the 1800's an editorial cartoon (or political cartoon, if you prefer the term) was a talked-about feature. Anyone who read a newspaper or one of

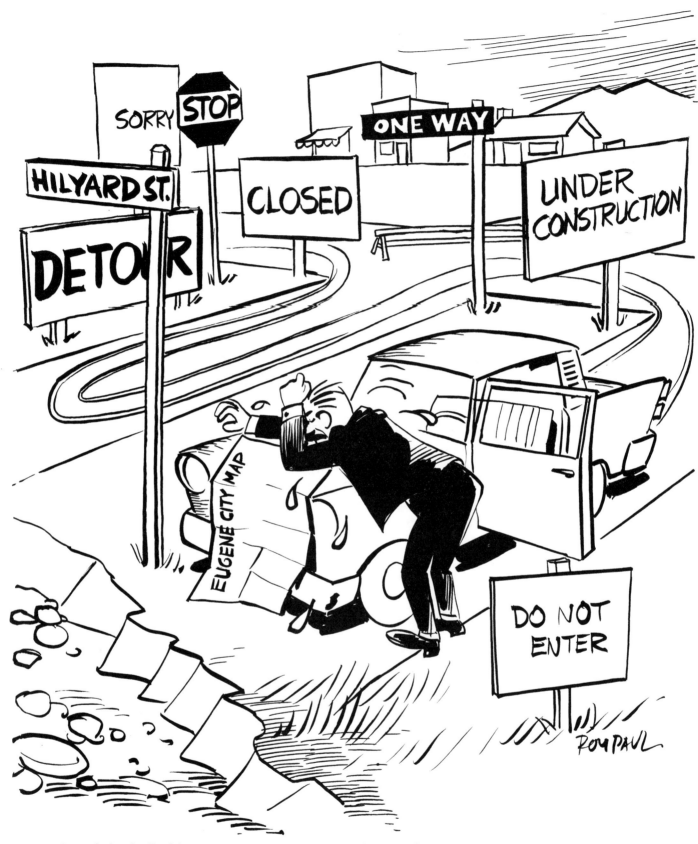

A purely local editorial cartoon commenting on construction around a main traffic artery.

the magazines like *Harper's Weekly* or *Puck* or *Judge* saw the prominently displayed cartoon, and, because he had less distraction from other media, he spent time with it. Undeniably, the cartoonist wielded a good deal of influence.

The editorial cartoonist today, then, has less chance to display his work, is more inhibited, is less influential. But, if the fine art of political caricature has lost ground, it is still the most rewarding of all the areas of work for the cartoonist.

THE CARTOONIST'S POLITICS

The editorial cartoonist who is a political conservative probably has more of a chance to get a newspaper job and keep it than the one who's a liberal. The majority of American newspapers are conservative.

Regardless of a cartoonist's politics, he is bound to run afoul of the views of his editor from time to time. Even Herblock occasionally is put down by his normally open-minded Washington *Post and Times-Herald*. When his paper decided in 1952 to support Eisenhower, Herblock, who was for Stevenson, found it convenient to take a vacation just before the election. Then there's the Democrat Burges Green, nephew of Senator Theodore Green and editorial cartoonist for the Providence, Rhode Island, *Journal.* He'd go along with a cartoon basically favorable to Eisenhower, but he'd put a stupid look on the President's face. Tactfully, so as not to alienate Green completely, for he is one of the more imaginative of the nation's editorial cartoonists, the chief of the editorial page would suggest a change in the facial expression, and dutifully the cartoonist would make the adjustment, hoping that next time it might slip by.

In his day Art Young would not put up with editorial changes. "As a choice between accepting the political judgment of the average newspaper owner and my own judgment as to what was best for my country and the future of mankind," he said late in life, "I voted in favor of myself." A commendable policy, if you can eat at the same time.

TECHNIQUE

The editorial cartoonist of today, in contrast to his

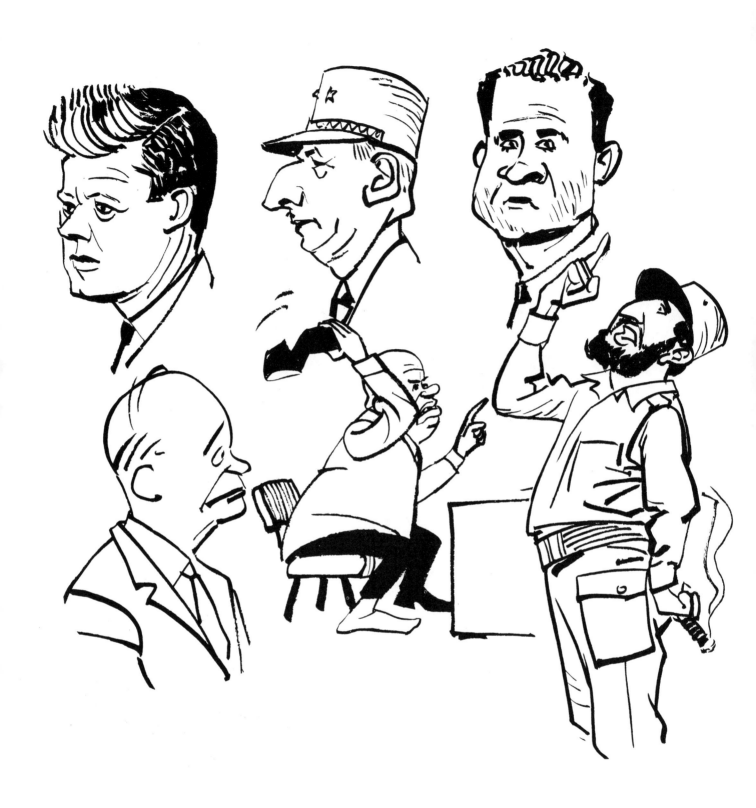

Caricatures of Kennedy, de Gaulle, Nixon, Eisenhower, Khrushchev, Castro.

counterpart in the 1800's, works in broad strokes. Today's reader can't—or won't—spend as much time with the editorial cartoon. The cartoon must be uncluttered. The message must be simple. A leader in the Uncluttered School has been Daniel Fitzpatrick, now retired from the St. Louis *Post-Dispatch* (see examples of his work in his *As I Saw It*, Simon and Schuster, New York, 1953).

The cartoonist uses brush and ink on a rough-textured paper, then applies shading with a lithographic or grease crayon.

Some editorial cartoonists with a humorous drawing style —especially those in Great Britain and on the continent—continue to work in pen and ink with Ben Day, in the manner of comic strip artists.

CARICATURE

An editorial cartoonist inevitably faces the problem of doing likenesses of persons in the news. Perhaps the town's mayor will have to be shown. Or a Senator. Or the President.

A realistic portrait is not good enough. The likeness should be an exaggeration, a caricature. The cartoonist wants his reader to recognize the public figure immediately through what William Murrell in his *History of American Graphic Humor* has called a "satiric exposing" of physical peculiarities and idiosyncrasies of manner. The features are exaggerated. The result, as someone has said (Murrell cites the phrase but doesn't name its originator) is "truthful misrepresentation."

It is a good idea to settle on the one most peculiar feature and overplay it: Kennedy's hair. John L. Lewis' eyebrows. Khrushchev's round, bald dome. Occasionally you run onto a character who is completely average-looking; he's not much fun to caricature. Most cartoonists abhor women—to caricature.

Caricature is best if it has an economy of line. Detail is to be carefully appraised by the caricaturist, then bit by bit discarded. Such "editing" is difficult. A caricaturist will tell you that it takes longer to attain a likeness with a few lines than to attain one with many lines. Phil May, years ago, was stopped by the head of his newspaper and told that, although his drawings

were clever, perhaps he was being overpaid. The last contribution had only seven lines in it, the newspaper head commented. "My dear man," May is said to have replied, "don't you realize that if I could have done it with five I would have charged you twice as much?"

The English caricaturist Hogarth earned the admiration of his contemporaries when he came up with his scene of a sergeant carrying a pike, entering an alehouse, followed by a dog—all in three strokes (a drawing that looked like a reverse "K").

There's an excellent book on the subject by one of the greatest caricaturists, William Auerbach-Levy, whose work you've seen in *The New Yorker*. It's *Is That Me?* (Watson-Guptill Publications, Inc., New York, 1947).

THE IDEA

There are two kinds of editorial cartoons: those that simply inform, like a news story, and those that comment, like an editorial. The latter are the most exciting and, I think, valuable; the former are the ones you most often see, because they're the safest and, frankly, they take less thought. If you want to see real cartoons of comment—beautifully drawn—get Bill Mauldin's *What's Got Your Back Up?* (Harper & Brothers Publishers, New York, 1961).

What the cartoonist does in an editorial cartoon is to liken a news event to something that is graphic. He works with similes.

In his spare time he builds up a bank of fables, proverbs, popular expressions and fads, well-known scenes from literature. When he hears Walter Lippmann compare inadequate American foreign aid to building a bridge halfway across a river or denounce the "domino theory" that if we allow one Asian country to go Communist they'll all go Communist, when he reads a charge made by the late Senator Richard L. Neuberger, commenting on Congressional attacks on Sherman Adams, that "It's a great deal like swatting flies rather than draining the swamp when you consider that many members of the House and Senate have accepted hundreds of thousands of

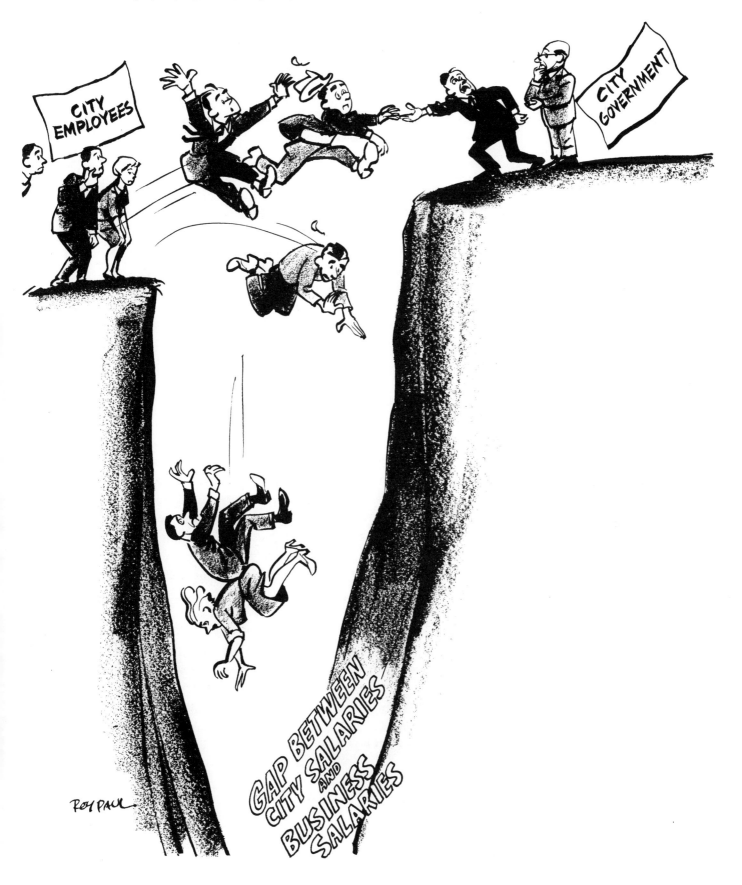

dollars in campaign contributions," he sees these as pictures that could be applied to different situations later. He jots them down.

When it's time to do a cartoon, he reads the news carefully, jotting down those items that deserve illustrating or comment. Then he browses through his idea bank, looking for analogies. Or he thumbs through picture magazines, catalogues and reference works. He might not find exactly what he's looking for, but his thinking will be stimulated.

The most powerful cartoon ideas are those that attack rather than praise, and those that convey irony.

Once he has the idea, he works out a number of roughs until he comes upon the one that presents his idea clearly and (this is important) logically. On a big newspaper the editorial cartoonist sits in on the daily conference of editorial writers to update himself on what's happening around the world and at home and what stands his newspaper is taking. He then works up several rough ideas, some of which have been suggested by the editorial board. The rough that most appeals to the editors is redrawn in final form.

THE USE OF SYMBOLS

The editorial cartoonist is able to cover as much ground as he does through his use of symbols. A tall, bewhiskered gentleman stands for the United States; a short, mustached man with a cigar for the typical taxpayer; a donkey and an elephant for the two political parties. Only a few cartoonists ever experience the thrill of developing a new symbol; once a symbol is in popular use, it is almost impossible to ignore it. Nor is the cartoonist inclined to give up an existing symbol.

There are some people who say that Uncle Sam as the symbol for the United States should be abandoned. Primarily a farmer type, he was developed at a time when this country was agrarian; we need a figure more up to date. The suggestion is not likely to gain ground. Allan Nevins' "Is Uncle Sam Obsolete?—A Fiery Debate" in the April 26, 1959 *New York Times Magazine*, for instance, brought cries from cartoonists all around. Hugh Haynie of the Louisville *Courier-Journal*,

SOUR NOTE

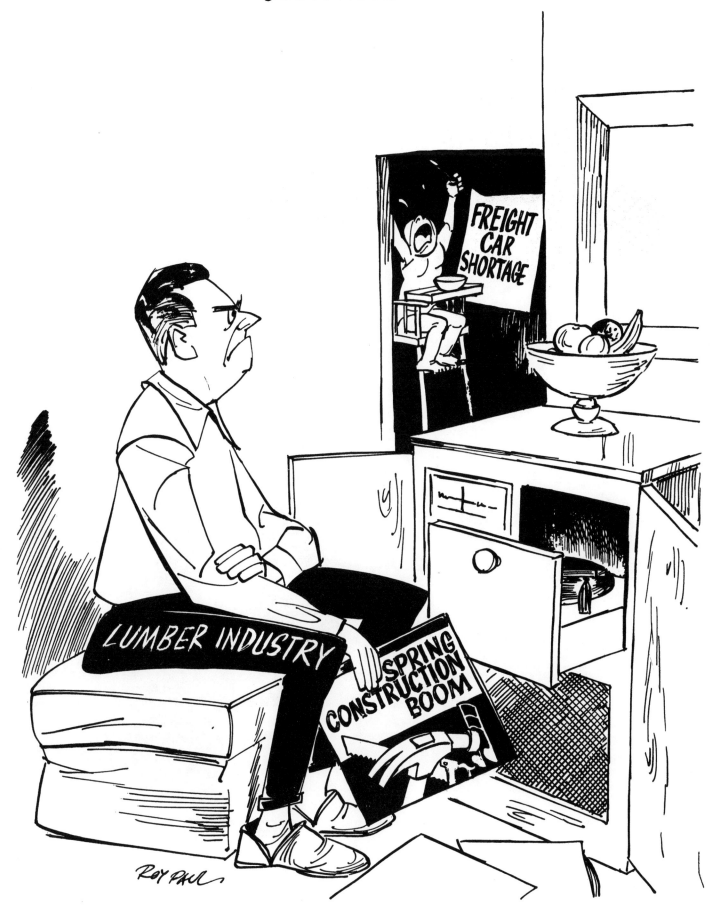

sounding off against the scholars united against Uncle Sam, probably reflected the thinking of other cartoonists when he declared: "We won't give up our cherished stereotype and, in our graphic medium, we, the chorus of frogs, will, in the fullness of time, drown out your thunder from Olympus. Thus, gentlemen: say 'Uncle'."

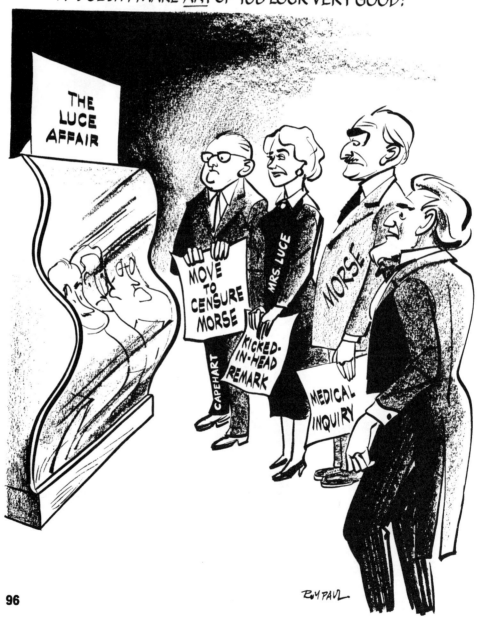

12

Illustrative and Advertising Cartoons

Some of the people who do illustrative and advertising cartoons also do the types of cartoons described in the last few chapters. They may be invited into the illustration and advertising fields because they are known cartoonists and their work, recognized by readers, carries added impact. Other people who do illustrative and advertising cartoons specialize in these forms of cartooning; generally they are not so well known as their contemporaries in the editorial cartoon, comic strip and gag fields.

How does the work of an illustrator-cartoonist or an advertising cartoonist differ from the work of other cartoonists? The main difference, I think, is that the ideas for illustration of either a story or an ad come often from the editor or advertising agency. But obviously, in this area as in all others, the cartoonist who has ideas of his own is more valuable than the pure draftsman.

THE JOB OF THE ILLUSTRATOR

Very often the illustrator of a magazine or newspaper story is offered a manuscript to read with instructions to look for a sentence, paragraph or scene that could be illustrated. The illustrator may be given an over-all size and be told which medium to use. The illustrator looks for something in the story that can be dramatized.

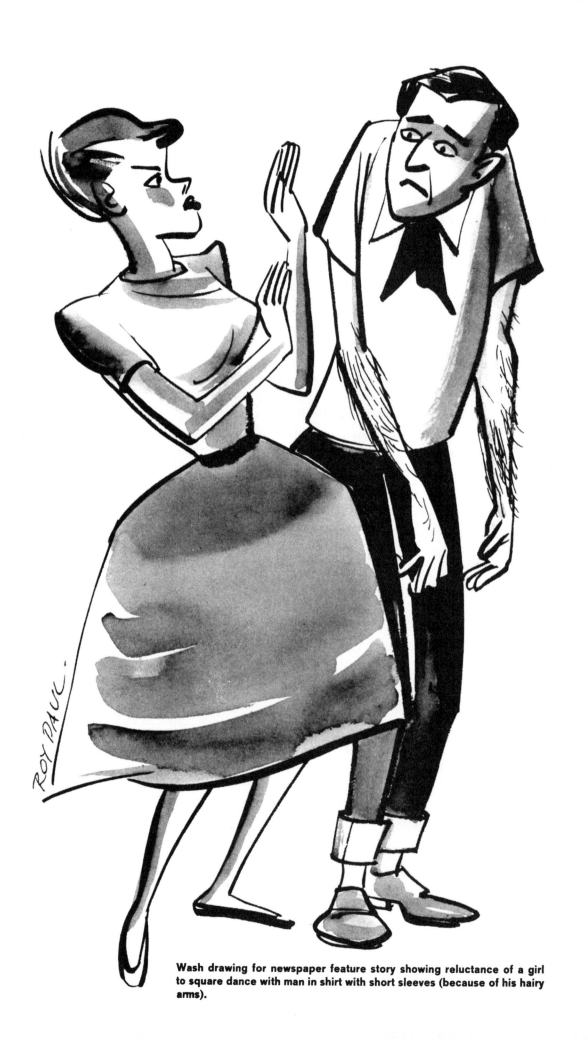

Wash drawing for newspaper feature story showing reluctance of a girl to square dance with man in shirt with short sleeves (because of his hairy arms).

Line drawing for newspaper story on how to keep Christmas tree from drying out.

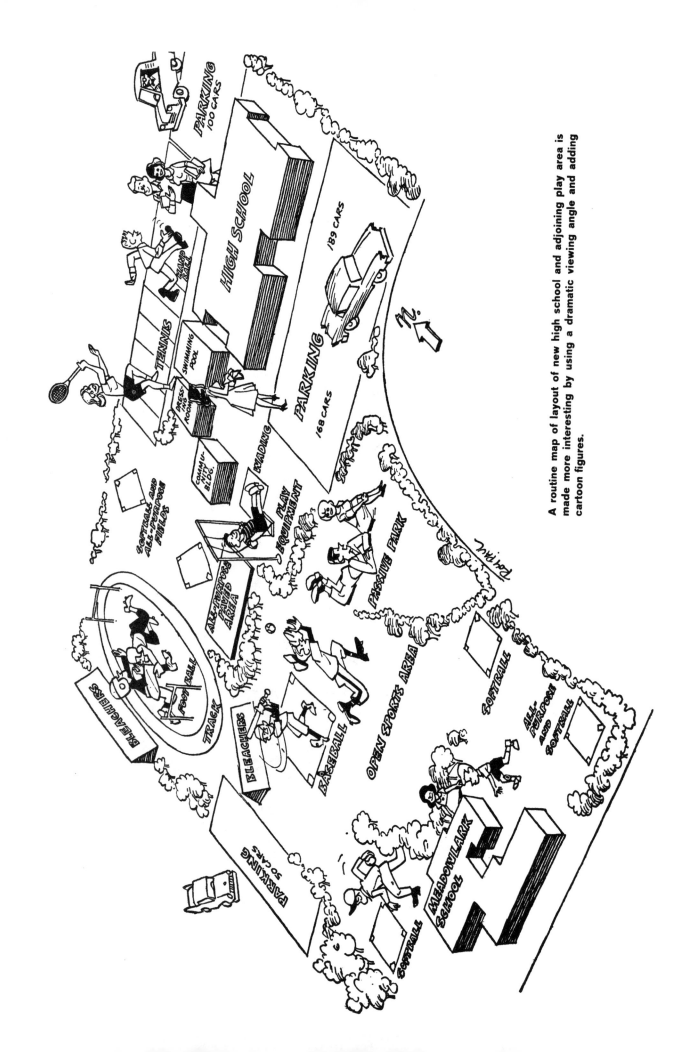

A routine map of layout of new high school and adjoining play area is made more interesting by using a dramatic viewing angle and adding cartoon figures.

Along with the cartoon assignments are likely to go some map-, graph- and chart-making assignments. These need not be strictly line-ruling or compass-using jobs. A few cartoon characters can brighten up a parade route, add interest to a trip map, make a chart more readable.

You'll use a pie chart to show percentages, a bar chart to show number of units one year as compared to the number of units the year or years before, a line graph to do the same work a bar chart does but in more detail.

You may be called upon to do a cutaway drawing (showing how some item is constructed), a flow chart (showing how a product is manufactured), an organization chart (showing the chain of command of an organization) and other kinds of charts. In each case, cartoons will brighten the appearance.

THE JOB OF THE ADVERTISING ARTIST

Cartoonists have long had a role in the preparation of advertising, but in recent years, especially since the era of the "soft sell," their role has taken on new importance.

In few cases, however, does the cartoonist poke fun at the product he is trying to sell. The advertiser's sense of humor is not likely to be developed to *that* degree. The cartoonist must

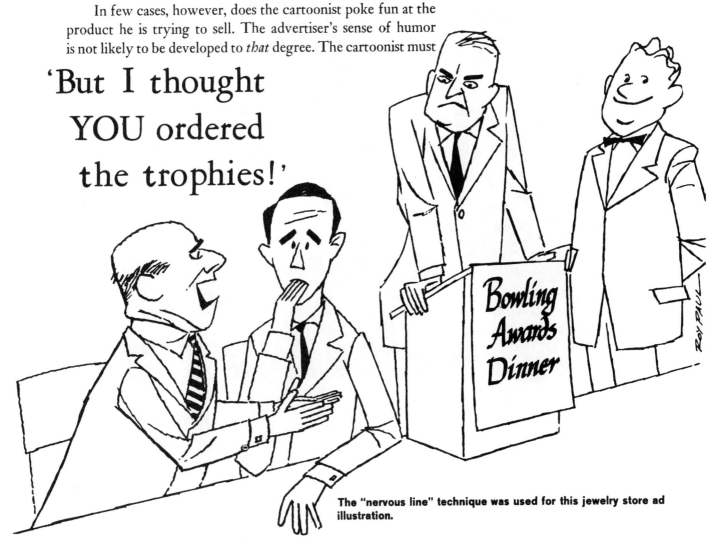

'But I thought YOU ordered the trophies!'

The "nervous line" technique was used for this jewelry store ad illustration.

A stylized drawing for an electric co-op ad.

realize that his sole purpose is to sell. If the advertising cartoon doesn't sell, even though it amuses, it is not successful.

Even that staid, formal type of advertising known as "institutional advertising" makes use of cartoons, although there is more resistance here than in product advertising. But let a cartoon in the news or editorial section poke fun at some industry or profession and listen to the howl! "It's . . . an irony that some of the most conservative professions which scorn the use of cartoons in their public relations as being ineffective become acutely aware of the sudden destructive power of a cartoon when it relates to their profession," comments Dave Breger in . . . *But That's Unprintable.*

The cartoonist who works with advertisers, especially if he does direct mail advertising, will eventually find himself called on to *lay out* an ad. He has a block of copy, a headline, an illustration, a signature; his job is to arrange these elements in a pleasing, practical design. Usually he starts with thumbnail sketches (sketches on a very small scale). When he produces one that has possibilities, he redraws it actual size. This full-size rough, with copy indicated by a series of ruled parallel lines, serves as a preview for the client and a guide for the printer.

HOW DO YOU STACK UP?

LUMBER BUYER PERSONALITY TEST INSIDE

Cover design and drawing for leaflet for a lumber company. This appeared originally in two colors.

ABCDEFGHIJKLMNOPQ
RSTUVWXYZ

abcdefghijklmnopqrstuv
wxyz

1234567890

ABCDEFGHIJKLMNOPQ
RSTUVWXYZ

abcdefghijklmnopqrstuv
wxyz

1234567890

13

Lettering

For some reason I never get a laugh out of my students when I tell this story.

It concerns a fellow who goes into a bakery and orders a cake to be baked in the shape of the letter "S." The baker says it'll cost extra because a special pan will have to be made to hold it. That's all right, says the customer.

When he calls for the cake the next day, he's disappointed. "But your cake is a gothic 'S.' I wanted a roman 'S.'"

The baker agrees to do it over, at an additional cost.

When the man returns, he is delighted. "That's just right!"

"Shall I box it for you?" asks the baker.

"Oh, don't bother," says the customer. "I'll eat it right here."

I still think the story is funny. It's a good illustration of how attached a man can become to type design.

Appreciating lettering is one thing. Doing it is another. To a cartoonist, lettering is perhaps the least satisfying phase of his work. It is more disciplined than other phases. There is less chance to exaggerate. It requires more concentration. But unless a cartoonist learns to produce good lettering, he'll have trouble passing as a professional.

Good lettering is lettering that is readable.

With lettering, there is little chance for inventive handling. The type faces which have taken years to design and which have been with us for centuries are the easiest to read. The cartoonist bases his alphabets on existing type faces, with only minor variations.

TYPE FACES

The two principal type faces (typographers sometimes call them type *races*) are (1) roman and (2) sans-serif, or gothic. The roman letters are characterized by main strokes that are both thick and thin and by short strokes, called serifs, at the ends of the main strokes and running perpendicular to them. The sans-serif letters have strokes of uniform thickness and, as the term "sans-serif" suggests, are without serifs.

Before attempting any lettering of your own, you should make a thorough study of these two alphabets. Notice that some of the letters, notably the "M" and "W," are wider than the others. The "I" and "J" are narrower. Among the lower-case letters, or noncapitals, the "f," "i," "j," "l" and "t" are narrower than other letters. You'll note that even among those letters that appear to be the same width there are subtle size differences.

It will help you to remember which strokes in the roman alphabet are thick and which are thin if you pick up a Speedball pen point in the "C" series (a chisel-like point), turn it counterclockwise to a slight angle and draw the letters of the alphabet. You'll notice that on the down pull you get a thick stroke and on the across pull you get a much thinner stroke. On diagonal pulls that move from top left to bottom right your strokes are thick; on those that move from bottom left to top right the strokes are thin. There are some exceptions to these rules, particularly in the down strokes of the letter "N."

There are other races of type besides the roman and the sans-serif. For instance: text (Old English); script (like handwriting); ornamental (which includes type with frost at the top to suggest cold, type made from sticks of wood to look rustic, etc.). There is also a style of type, not important enough to be considered a race, that has strokes of the same thickness (as in sans-serif) but also has serifs (as in roman). This is called square serif type.

Within each of the major type *races* are many different type faces, each with distinguishing characteristics. Take the roman race, for example. If the difference between the width of the thick strokes and that of the thin strokes is minor, the type is considered Old Style; if the difference is pronounced, it is Modern Style. These various kinds of types within the races are referred to as type *families*. The particular family represented in the roman alphabet included with this chapter is Garamond. The family represented in the sans-serif alphabet is Tempo. Right now you are reading Janson (roman). Headings and the captions accompanying some of the drawings are in Grotesque (sans serif).

Even within the families there are differences. There are bold types and light types (our Garamond and Tempo happen to be bold versions of their families), condensed and expanded, italic and upright.

The cartoonist, for most of his work, is concerned only with sans-serif types, and usually only with capital letters.

BALLOONS

Most of the lettering a cartoonist does consists of talk coming from one or more of the characters within a panel. All

Some typical headings and logotypes cartoonists are called upon to do, hand lettered, except for "THE CLASSES" and "Shop," which were set in Craf-Type.

comic strips make use of these "balloons," as do many of the editorial cartoons.

Use a T-square to rule a series of guidelines for your lettering. I have found it helpful to make my own special ruler for spacing these lines. With this kind of a device, all you have to do is place it against a line perpendicular to either the top or bottom border of the strip and mark off the space divisions. You'll be more pleased with your lettering if the distance between lines of lettering is a little less than the height of the letters.

The lettering is roughed in with a pencil, then traced over in ink. Most cartoonists use some sort of a nonflexible, stubby pen point for balloon lettering. Any of the Speedball pens, in the smaller sizes, can be used.

It's important to put some thought into the spacing between letters. It is not correct to put, say, 1/32 of an inch automatically between *each* letter. Such a space between the outside edges of a capital "H" and a capital "L" looks a great deal narrower than a similar space between the outside edges of a capital "V" and a capital "A." Optically, the spacing should be the same. This means that you *compensate* in the spacing when you get certain combinations of letters in your words.

It is a good idea in balloon lettering to push all letters closer together than normal. You'll also want to stick in an occasional heavy word for emphasis. The right bend in the "D" is often sharpened to help distinguish it from the "O." The letter "J" is often supplied with a short cross stroke or serif at the top, even though the alphabet is sans-serif. The "I" gets similar treatment.

Undoubtedly you will develop some distinguishing characteristics of your own as you do more lettering for your cartoons. Such gimmicks should be kept to a minimum because they can hinder rather than help readability.

14

An Audience
For What You Draw

It may be that you are not really interested in—or qualified for—selling the cartoons you draw. Even though cartooning to you is nothing more than a hobby, you need not consider it a purely private activity. There are many ways in which other persons can share the fun with you.

If you're involved in the planning of a dinner, you may want to draw some place cards, capturing in cartoons the personality of each guest, or, if it's a large group dinner, the personality of each guest at the head table. If you teach a Sunday school class, you may want to work up your own visual material rather than rely on nonlocal material available from the religious bookstores or denominational headquarters. If there are posters to do, one or two of your cartoons could brighten the several lines of show card lettering. If there is a room to decorate, you might want to try a mural on one wall.

One warning: Don't try *any* of these jobs if you don't want to be called on by your friends for similar jobs! A consolation: You'll never have to worry about income tax on these jobs because, unless you have a different type of friend from those I have, there'll be no messy exchange of money.

It would be hard to imagine a cartoonist, even one who regards his drawing as only a hobby, who does not decorate his letters with cartoon figures. Such decorations, of course, make letters a good deal more interesting.

If you enjoy getting up in front of an audience, you may find the almost lost art of the chalk talk an interesting idea. Once you work up a clever routine and give it, you'll find the word will get around quickly. You'll soon be on the fried chicken and string bean circuit. In giving chalk talks you should work on the largest available sheets and in thick, heavy lines.

If you're good at caricature you can revive a sagging party by dashing off likenesses of the guests. Ask questions of your subject as you draw—sound him out for his occupation, his hobbies and peculiarities—and work one or two of these in as side sketches. Give him a large head and a tiny body. A caricaturist who visits each of the fraternities on several campuses in the West each year does sketches of each member, charging two or three dollars apiece, making his living that way.

For all of these jobs you need not worry about how the work will reproduce. You may use color lavishly, with no worry about increased engraving and printing costs. In fact, if you *don't* use color, you are cheating yourself. The professional cartoonist doing work for reproduction in a periodical would give anything for the hobbyist's complete freedom to work in any medium and with any color on any surface.

CHRISTMAS CARDS

A most logical activity for the cartoonist-hobbyist is the production of Christmas cards or other greeting cards. These may be done by hand; they may be produced via linoleum block or silk screen processes; or they may be printed commercially.

It is possible to buy paper and matching envelopes, especially prepared for this purpose, or, of course, it is possible to cut and fold your own. If you cut out your own envelopes, make a master pattern on cardboard and trace around it for each envelope.

The ultimate in Christmas card production is to make a special, appropriate original card for each friend. When a long list prohibits this, it is a good idea to make two or three master cards on tracing paper and transfer the designs to the card (by shading the back of the original drawing with a soft pencil and

then tracing over the drawing with a hard pencil), then finish in ink. If you can afford a few tools and a necessary hand press, you should consider getting a kit for linoleum block printing or one for silk screen printing. Your art store can show you how these work.

Many cartoonists cannot take the time to do each card by hand or to do their own printing, so they turn out a piece of artwork and hand it over to a commercial printer. The card can be done in pen or brush and ink, the type set in Artype or Craf-Type (letters printed on sheets of Cellophane that can be applied to the drawing as Zip-A-Tone is applied), and art and type are turned over to a small shop which specializes in multi-lith printing (an inexpensive form of offset lithography).

Some cartoonists who've done Christmas cards of their own have toyed with the idea of doing cards to order and selling them; some have followed through on the idea and made and are making a handsome profit. Others have sold their work to greeting card companies. The writers' magazines and the cartoonists' newsletters carry information on these markets.

SELLING YOUR WORK

At a number of places in these lessons I have offered advice on how to sell your cartoons. There are some jobs where a cartoonist is regularly employed and gets a regular pay check. But usually, when we speak of selling cartoons, we mean selling them on a free-lance basis.

I have a free-lance arrangement to sell editorial cartoons, but such cartoons are usually staff-drawn. Comic strips are sold on a contract basis. Animated cartoons are usually produced by salaried workers. But gag cartoons, illustrative cartoons and many advertising cartoons are produced by free-lancers. In some cases the editor or client pays a rate he has established (usually true for gag cartoons) while in other cases the cartoonist sets his own rates (usually true for advertising cartoons). On jobs where the cartoonist bills the client, he works for from four to ten dollars or more an hour, depending upon his experience, speed, reputation and, in some cases, the ability of the client to pay and the type of client involved.

It's best to sell your work in person. Gather together your most impressive samples, including, if possible, examples of work that has been published; make an appointment; be there on time. You may show some already drawn cartoons you want to sell.

Most of us do not live in the large cities where general circulation, national magazines are published. But in nearly every city of any size there are regional magazines, local newspapers, TV stations, advertising agencies, print shops and advertisers.

A FINAL WORD

Cartooning is too lively an art to be confined to a set of rules. As you become familiar with its possibilities this truth will become more evident to you.

Yet we have to start somewhere. I have attempted, in these lessons, to draw some generalizations from the work I've studied and the work I've done. The fact that at times you did not agree with me shows that you have been doing some thinking on the subject. If I've succeeded in getting you to do that, I've succeeded, I think, as your teacher.

It's necessary to start with rules, but rules are meant to be broken.

You may have heard of the stutterer who asked the pilot of a small private plane: "C-c-c-can I have a r-r-r-ride?" The pilot said yes, and then explained what should be done in case the plane ran into trouble. "If you have to bail out, count to ten and pull the rip cord."

Well, the plane developed engine trouble in the air. The pilot motioned to the stutterer to jump. The stutterer was hesitant. So the pilot jumped, not being able to wait for his passenger any longer. Floating down to earth, he saw the stutterer finally leave the plane, but his parachute did not open. As the stutterer plummeted past the pilot, the pilot heard the stutterer say: "T-t-t-t-two!"

If the rules don't apply in your case, ignore them. Sometimes it's necessary to pull the rip cord *before* you count to ten.